A CENTURY IN PICTURES

COMPILED BY
THE NEWS-GAZETTE

Published by Sports Publishing Inc.
www.News-Gazettebooks.com

A CENTURY IN PICTURES

RON WILCOX, Series Editor

JASON QUACKENBUSH, CAROL LOMBARDI, AMY ECKERT, PAT KUCHEFSKI, Photo Research

R. K. O'DANIELL, JOAN MILLIS, Photo Scanning

JOANNA WRIGHT, Developmental Editor

TERRY NEUTZ HAYDEN, Cover and Interior Design

DAVID HAMBURG, Copy Editor

MICHELLE SUMMERS, Interior Layout

JULIE L. DENZER, SCOT MUNCASTER, Production

ISBN 1-58261-242-0

Library of Congress Number 99-68245

Published by Sports Publishing Inc.

News-Gazettebooks.com

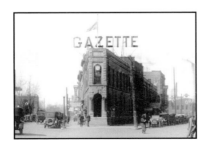

A Century in Pictures
is dedicated to
Mrs. Marajen Stevick Chinigo,
the owner and publisher
of *The News-Gazette,*
for her commitment to making the newspaper
a reflection of the community it serves.

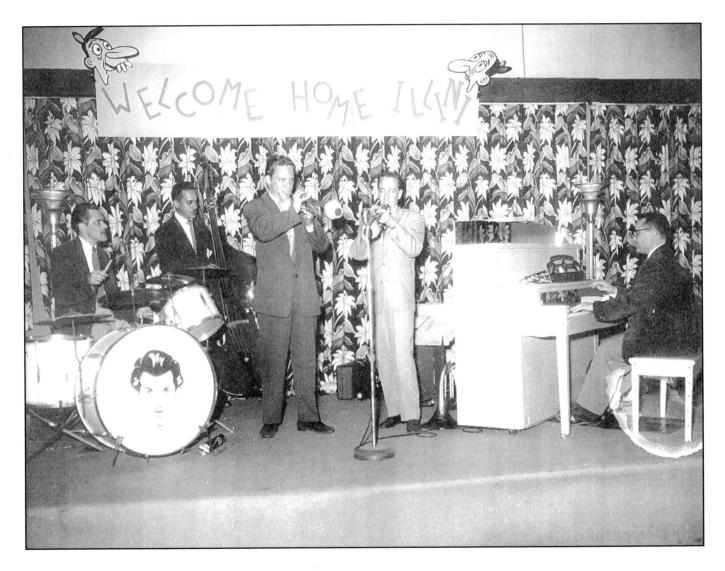

Lou Williams (drums), Pete Bridgewater (bass), Ernie England (trumpet, left), Rolf Erickson (trumpet, right) and Dick Webber entertain an audience at the 8 O'Clock Club on Route 150 East.

PHOTO COURTESY OF
MR. PETE BRIDGEWATER

Foreword

Someone once suggested that a good newspaper is like a community looking at itself.

And the waning days of the century seemed like an appropriate time for our newspaper to do just that—in the most literal way.

A Century in Pictures was created for publication in *The News-Gazette* over the last 100 days of 1999. From the beginning, we believed readers would be intrigued by the project. Everyone seems to like old pictures. But, to be candid, we were somewhat unprepared for the depth of reaction these photos would produce, including this opportunity to publish them in book form. We are most grateful. Principal credit rests with Ron Wilcox, who took an idea and made it a reality.

Some of the images that follow are of major events in local history. Some are of famous names. Some are of familiar places adorned with what are now largely unfamiliar names. I guess my personal favorites are the faces—faces both like our own and somehow different—of people who shared our space, if not our time.

A number of the photos are from the *News-Gazette* files. Others were generously shared from various collections. Together, they show us the face of our community in the 20th century, a face none of us will see for ourselves again.

East Central Illinois is a special place. We hope you find this book a fitting portrait of who we were and where we have been.

John Foreman
Editor and General Manager
The News-Gazette

Introduction

This collection of historic photos, *A Century in Pictures,* is the result of countless hours of work by a group of *News-Gazette* employees who wanted to capture the essence of a century filled with great stories. Stories can often be told best by images, so it was images we chose to tell the story of where we've been during the past 100 years. We affectionately referred to the task as "Project Snapshot."

A Century in Pictures was a project with three initial components. First, we hoped to chronicle in print the events that shaped our lives–from major news happenings to ordinary life in East Central Illinois. Every day, for the last 100 days of 1999, a different picture was published in the newspaper. Those pictures reflected politics, industry, family life, celebrations and disasters. Readers collected them and shared stories about them.

Second, we wanted to create an educational opportunity that provided school teachers with a daily "textbook" for use in the classroom. We developed curriculum materials that suggested specific classroom activities related to each photograph. Some teachers developed their own creative uses for the pictures. And students learned.

Finally, we looked forward, expanding the collection to a virtual community for our online readers at NewsGazette.com. The pictures were organized online chronologically, allowing readers to view them by decade. We also offered an opportunity for readers to reminisce by sharing their thoughts with us electronically. And we published selected questions from a 1964 community survey so our online readers could respond and then see how their responses compared with those of 35 years ago.

This book is a fourth component of the project. Many readers called, requesting that this collection be made available in a format they could easily keep and share with others. We listened, and then we worked with

A CENTURY IN PICTURES

Sports Publishing Inc. in Champaign to produce this book. *A Century in Pictures* contains many of the photographs that appeared in *The News-Gazette*. It also contains a few that didn't.

These pictures are not in any particular order. They're not of any singular subject. They're of both celebrities and faces unknown, of historic buildings and nondescript structures. They're of days with dirt roads and days of modern conveniences. They're life with a thread weaving through the generations. They represent a potpourri of who we were and who we are.

A Century in Pictures is a reality because of the people who have worked on the project. They represent dedicated *News-Gazette* employees who understood what we hoped to achieve with this project. They include Jason Quackenbush, *News-Gazette* in Education Coordinator; Carol Lombardi, Electronic Publishing; Sue Trippiedi, Director of Advertising; Amy Eckert, Special Projects Manager; Joel Rasmus, Marketing Manager; Dan Corkery, Managing Editor; and me serving as Committee Chairperson. It's also a reality because of the sponsors whose support has helped to place 250,000 newspapers in classrooms across East Central Illinois. These sponsors include Busey Bank, BankIllinois, Worden-Martin, TEAM, Fox Development, Dr. Thomas Standley, DMD, A.G. Edwards, Central Illinois Bank, Illinois Power and C&U Poster Advertising Company.

At every committee meeting, our attention inevitably turned from the details of the project to the details of the photos. It was difficult to narrow the pictures to 100. It was a fun project. And it's a project we're happy to be sharing with you.

We think it's a collection you'll enjoy well into the next century.

Ron Wilcox
Group Vice President
The News-Gazette

A Sweet Treat

A horse-drawn cart from the Harris Ice Cream Company
stops to serve customers at the corner of Hill and Randolph
streets in Champaign, near the building that served as
Champaign High School from 1893 to 1914.

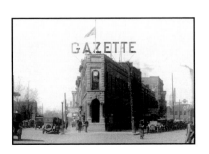

PHOTO COURTESY OF
THE CHAMPAIGN COUNTY
HISTORICAL SOCIETY

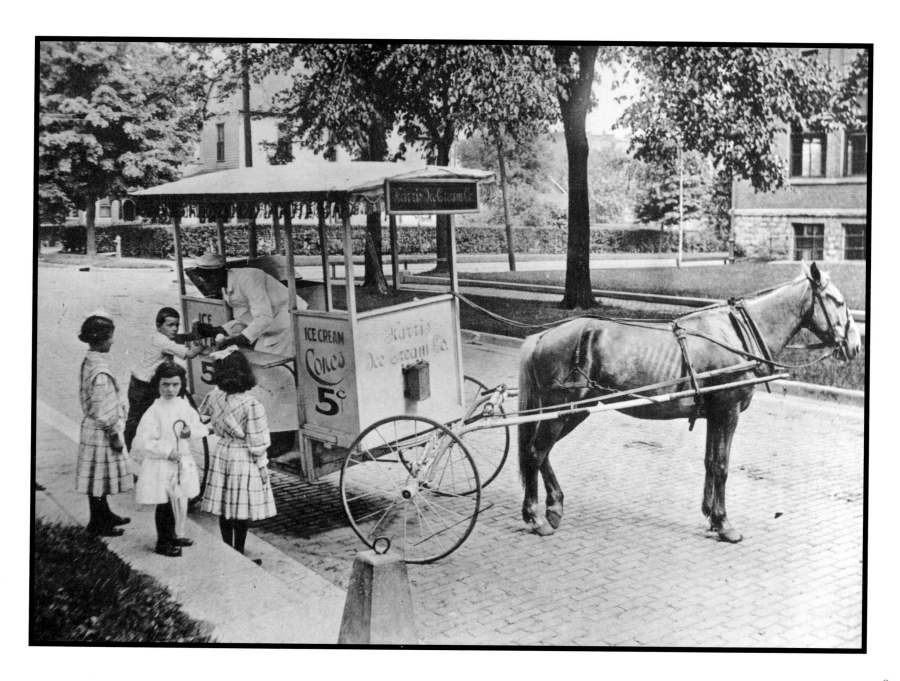

Field Cafe

Patrons visit the Field Cafe in P-3 at Chanute Air Force Base in Rantoul in the 1940s. During World War II, the building also housed 3,500 airmen and was nicknamed Buckingham Palace.

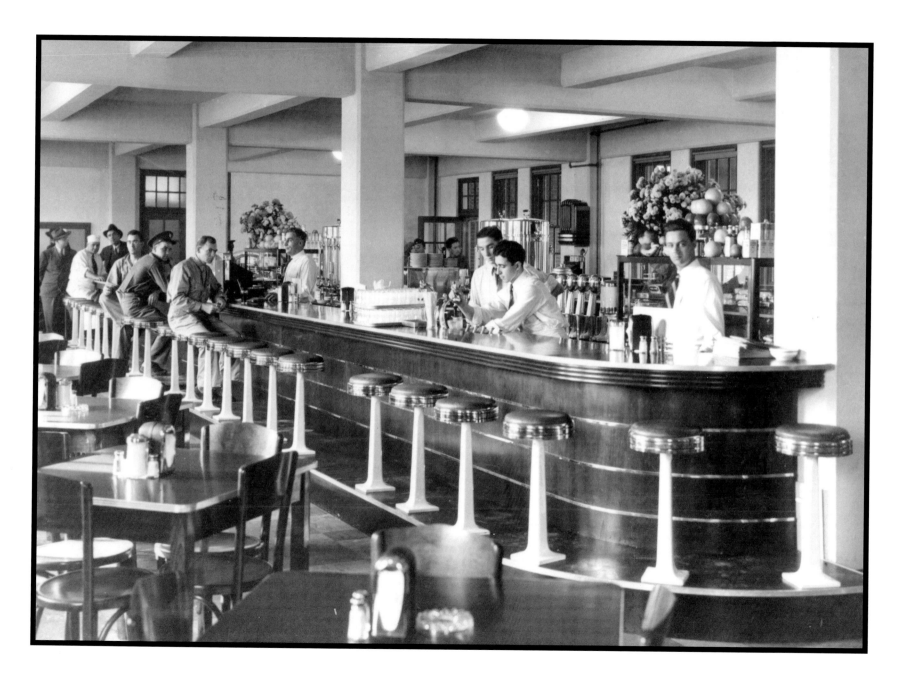

Preparing America for the 21st Century

President Clinton gestures while giving a speech at the University of Illinois Assembly Hall. Clinton visited Champaign-Urbana on January 28, 1998, during his second presidential term.

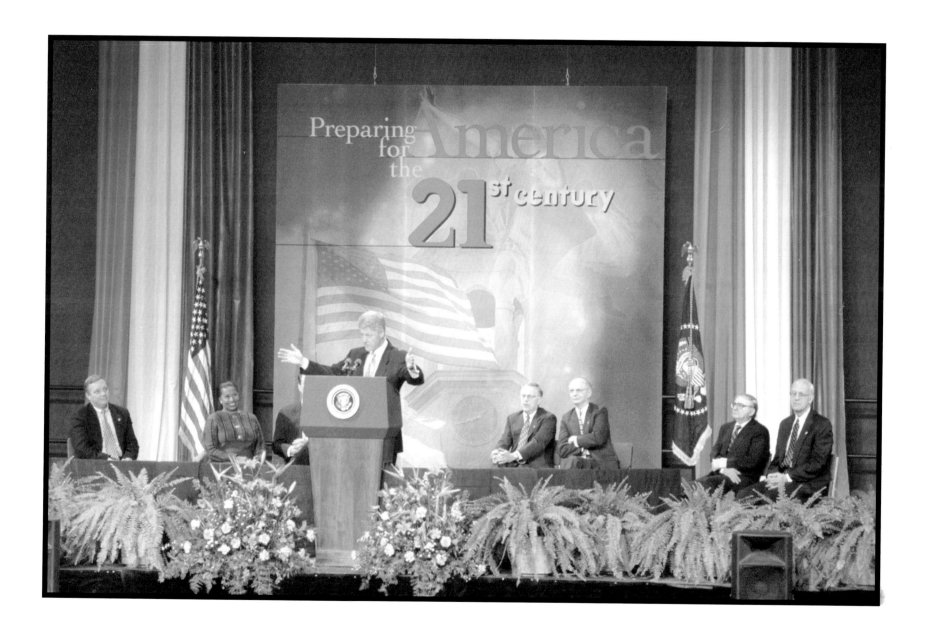

Traditional Fair

Passengers in horse-drawn carriages arrive on
Main Street in St. Joseph for the town's first Corn
Carnival and Fair in 1907.

PHOTO COURTESY OF
THE CHAMPAIGN COUNTY
HISTORICAL SOCIETY

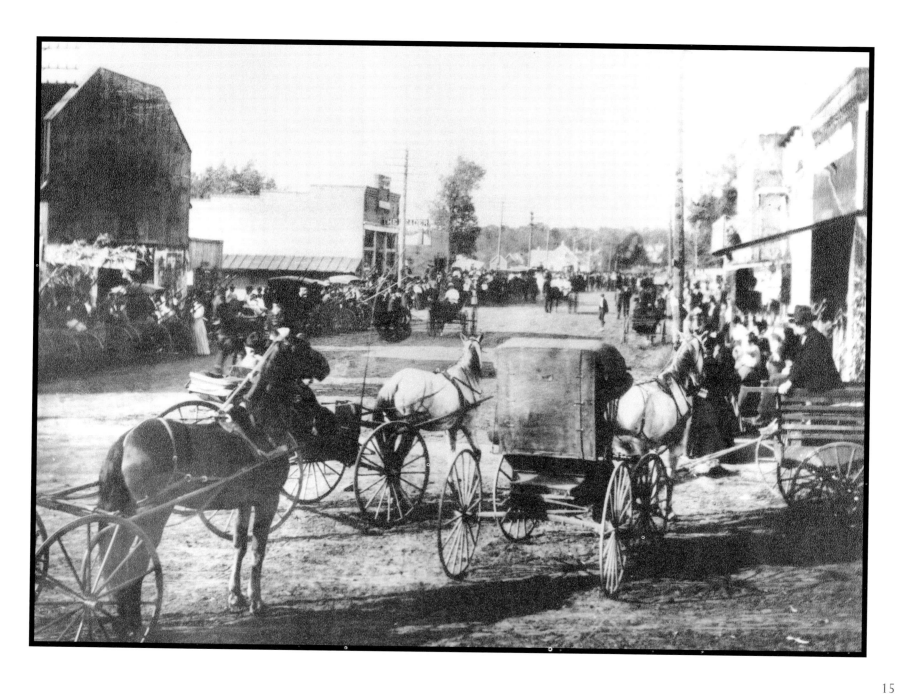

J.C. Penney Opens to Protest

A lone woman pickets J.C. Penney upon its opening in downtown Champaign in 1961, one of the first times in Champaign-Urbana history that African-Americans publicly protested their treatment.

PHOTO COURTESY OF
THE URBANA FREE LIBRARY

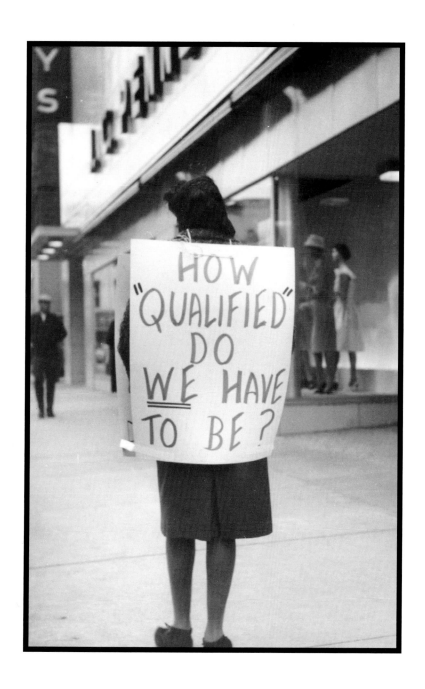

1915 Labor Day Parade

These members of the International Association of
Machinists decorated their truck with the Stars and Stripes
for the 1915 Labor Day Parade in Urbana.

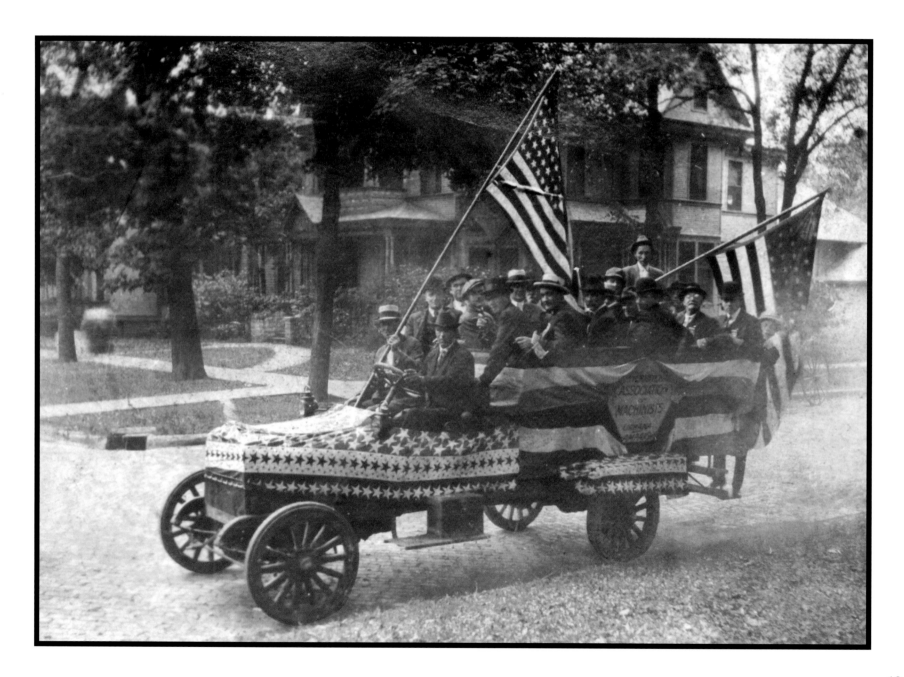

The Elephants Come to Town

Everyone loves a parade, especially a circus parade. Here, a parade of elephants marches through town to promote the Sells-Floto Circus appearing in Monticello.

PHOTO COURTESY OF
MRS. HELEN McFEETERS

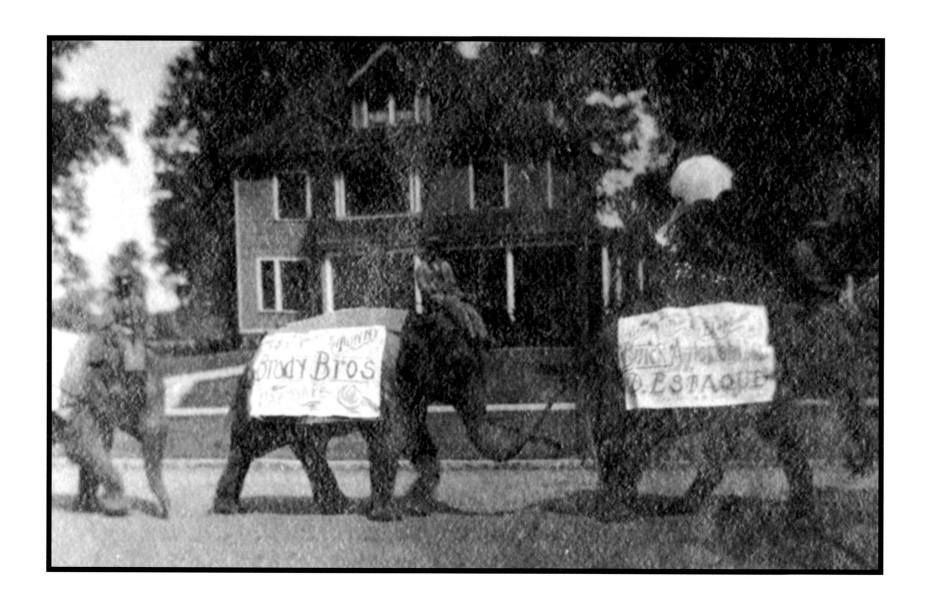

Changing Transportation

This view of Main Street in downtown Urbana in
August 1921 illustrates the progression from horses
to automobiles as a mode of transportation.

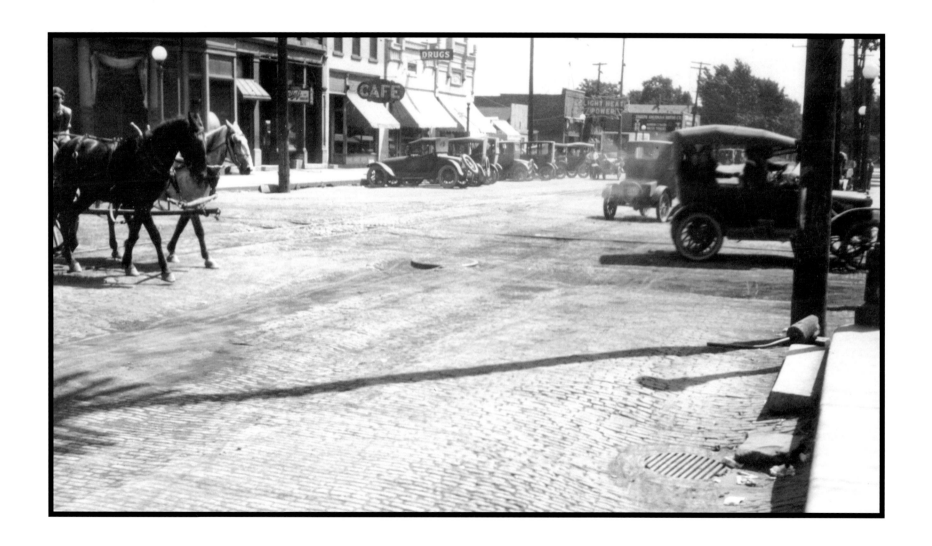

Grocery Shopping

Customers shop at Rice Grocery, later Dickenson's Grocery, in Urbana. The men behind the counter are Jim Alexander and George Rice.

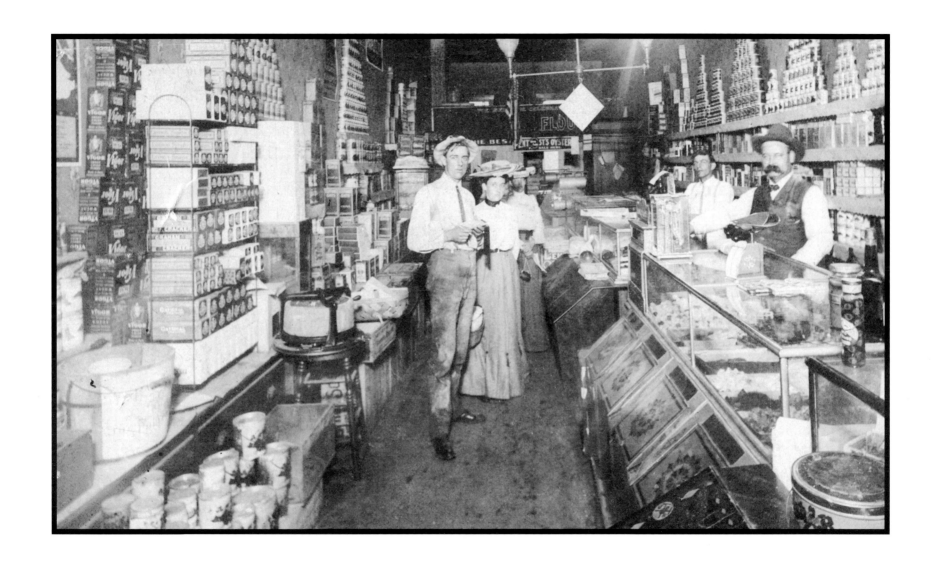

Champaign Wins Corn Belt League

This Champaign baseball team, the Le Roy Barnes Red Sox, won the tournament championship in the 1940 Corn Belt League.

PHOTO COURTESY OF
MRS. DORIS HOSKINS

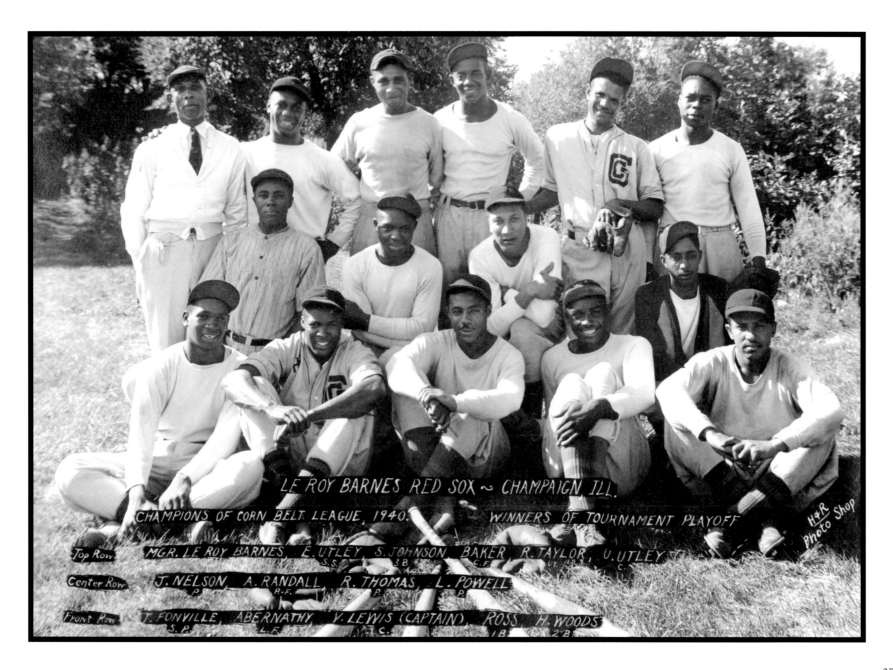

LE ROY BARNES RED SOX ~ CHAMPAIGN ILL.

CHAMPIONS OF CORN BELT LEAGUE, 1940. WINNERS OF TOURNAMENT PLAYOFF

H+R Photo Shop

Top Row MGR. LE ROY BARNES E. UTLEY S. JOHNSON BAKER R. TAYLOR U. UTLEY
 S.S. 3B. C.F. UT C.

Center Row J. NELSON A. RANDALL R. THOMAS L. POWELL
 P. R.F. P. P.

Front Row T. FONVILLE ABERNATHY V. LEWIS (CAPTAIN) ROSS H. WOODS
 S.P. L.F. C. 1B 2B.

Busey Bank

Busey Bank, pictured here in 1905, was located at the southwest corner of Main and Race in downtown Urbana. A modern Busey Bank facility occupies the same corner today.

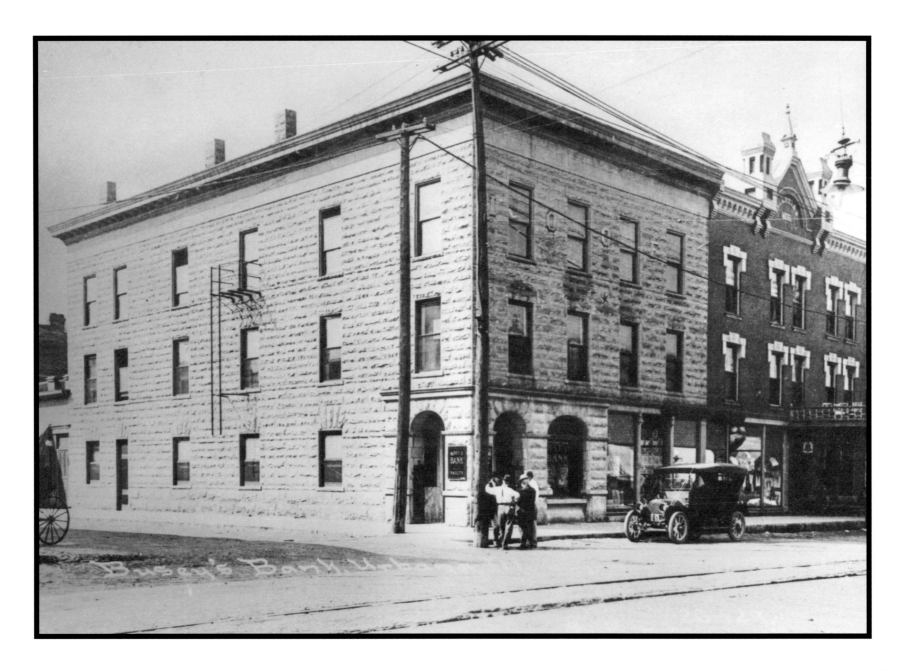

J.C. Caroline:
A Sporting Legend

In 1953, college football Hall of Famer J.C. Caroline led the nation in rushing and was named an All-American. He played with the Chicago Bears, was an assistant coach at the University of Illinois, coached at Urbana High School and is now in the physical education department at Urbana Middle School.

PHOTO COURTESY OF
THE URBANA FREE LIBRARY

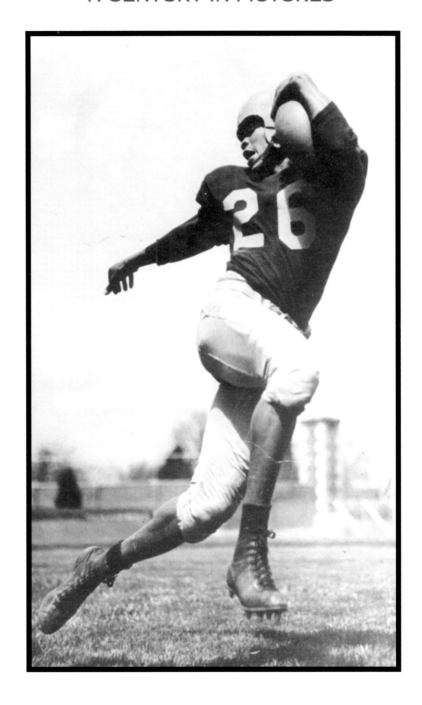

Twister Terror

A tornado sweeps across the Champaign County prairie in 1940. The State of Illinois is hit with an average of 28 tornadoes each year.

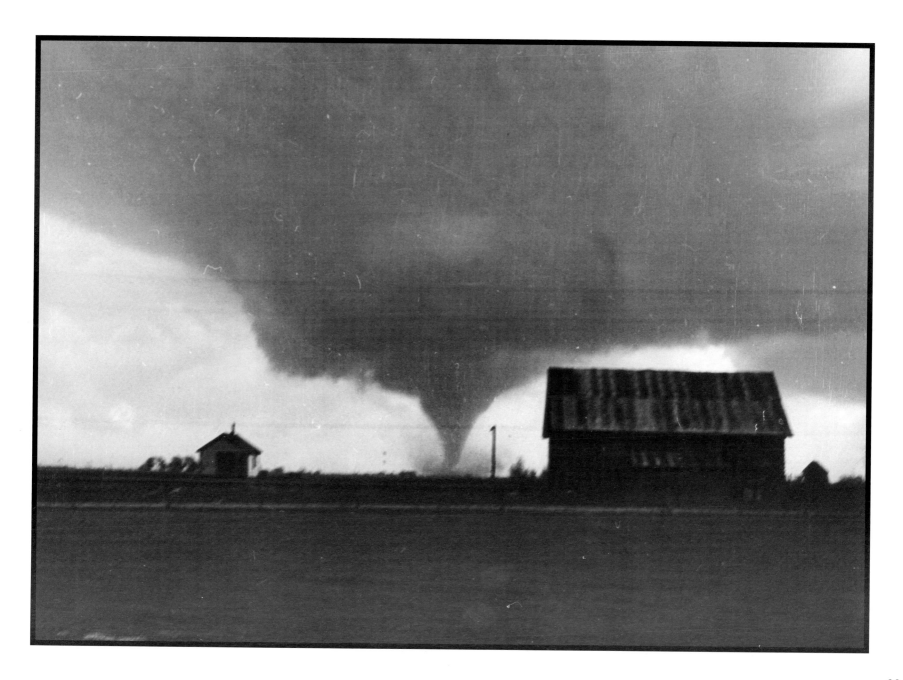

Roaring '20s

Local audiences enjoyed the music of Mac Scott and His "Footwarmers." From left to right, the band includes Dick Langford, Elwood Buchanan, Ernie Hite, Theophilous Mann, Doris Baker (Hoskins), Mac Scott, Chauncey Ryder, Porter Lewis and Arthur Penny.

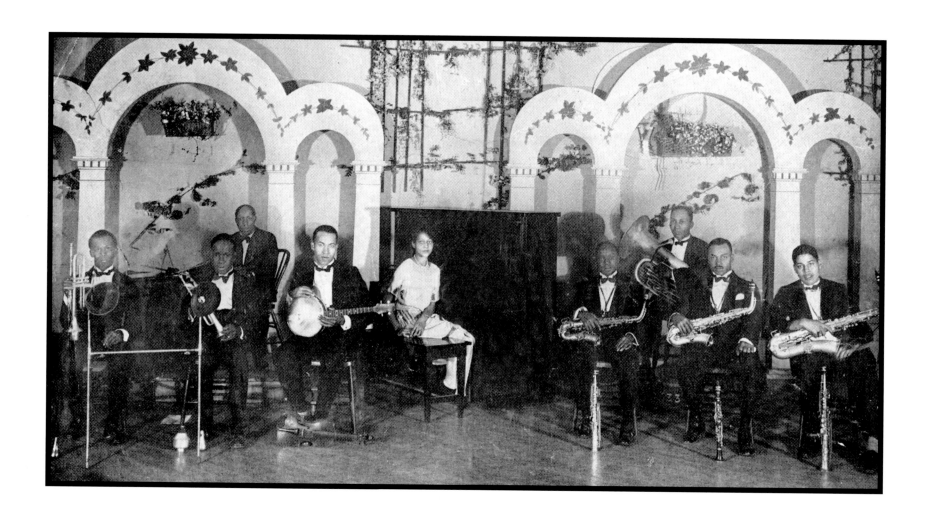

A New Sales Industry

As the years passed after the turn of the century, automobiles became a more popular form of transportation. This business, on Neil Street in Champaign, served automobile owners as well as those who still preferred the more traditional horse and buggy.

PHOTO COURTESY OF
THE CHAMPAIGN COUNTY
HISTORICAL SOCIETY

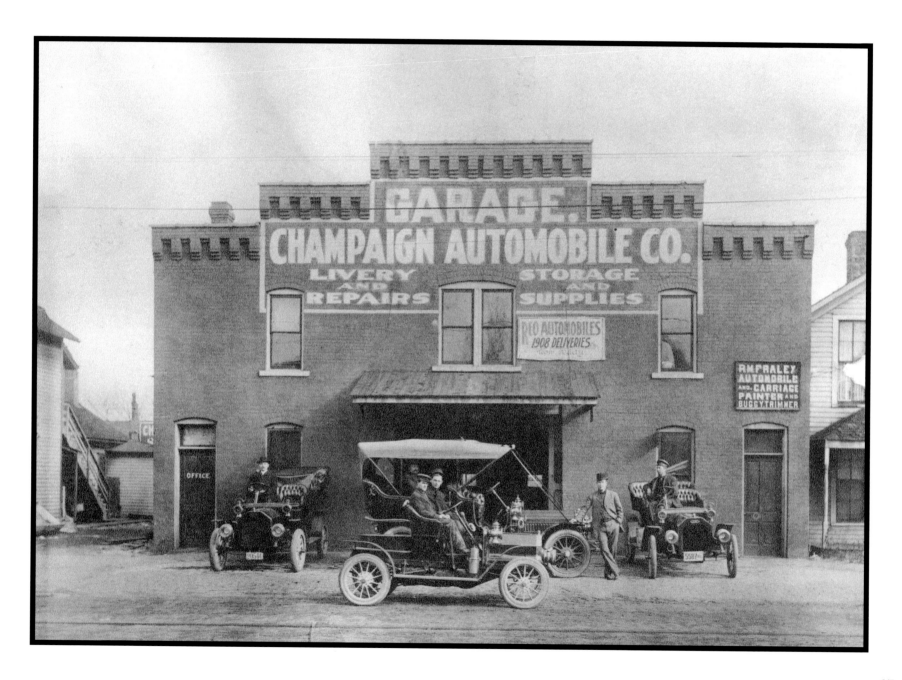

An Engineering First

William Walter Smith graduated from the
University of Illinois in 1900. The Broadlands native
was the school's first African-American graduate and
went on to become a successful engineer.

PHOTO COURTESY OF
THE URBANA FREE LIBRARY

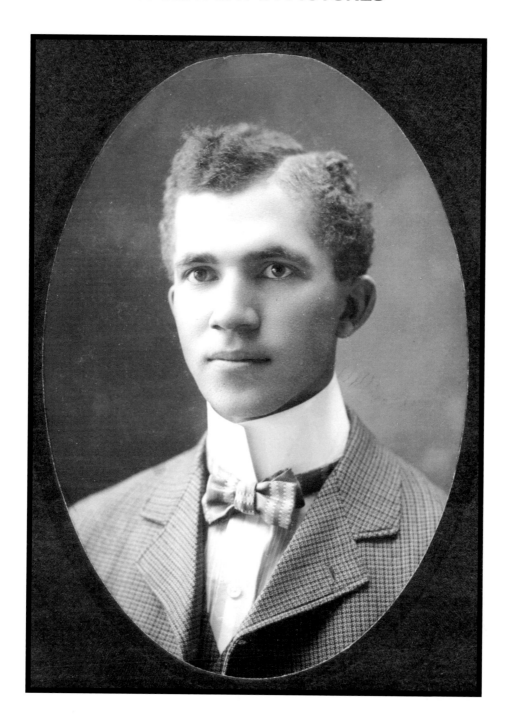

We Liked Ike

Presidential candidate Dwight D. Eisenhower addresses a Champaign audience during his 1952 campaign. He would go on to serve two terms as our 34th president.

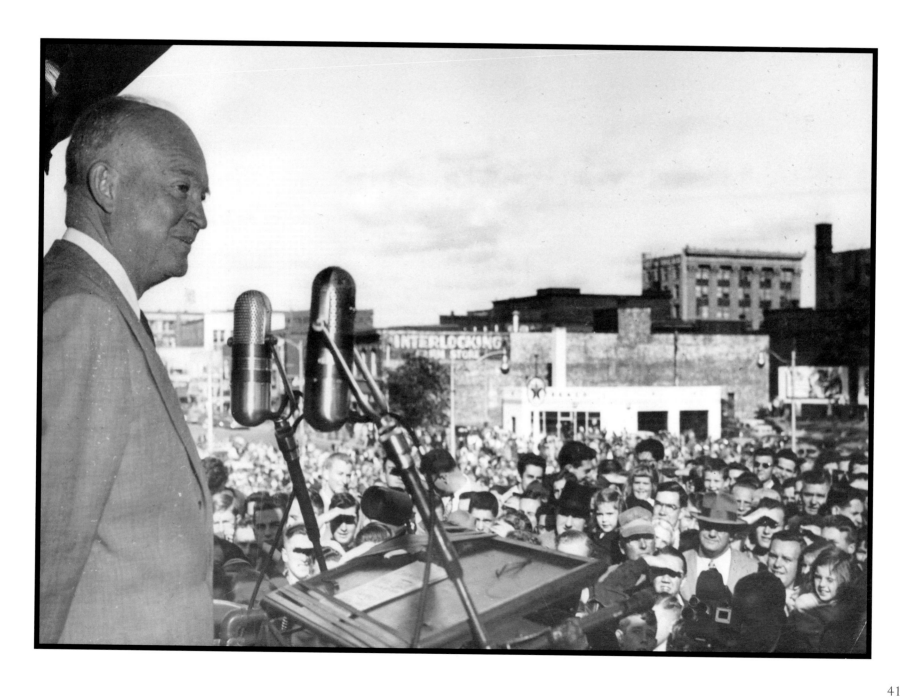

Miss Hawkins

Mae Ryan Hawkins, an Illinois State University graduate, was the first African-American teacher in Champaign. She was paid $90 per month to teach at Lawhead School in 1934.

PHOTO COURTESY OF
MRS. DORIS HOSKINS

Interurban Car #137

Founded by William B. McKinley, cousin of the president, the
Illinois Traction System eventually linked Champaign with
Danville, Decatur, Springfield and St. Louis. This photo of #137,
providing Champaign-to-Danville service, was taken in 1905.

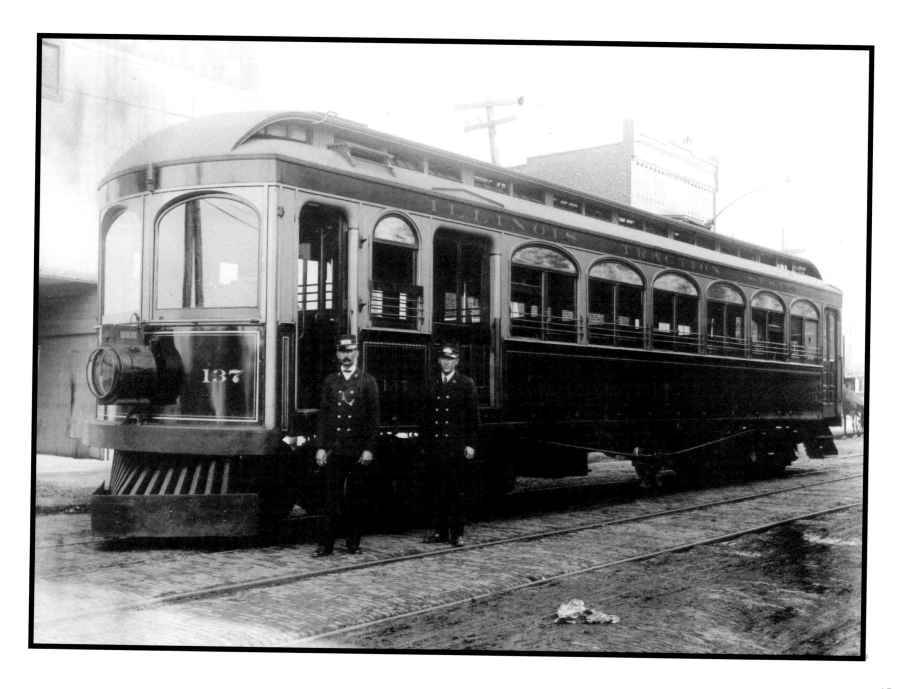

Workin' on the Railroad

Shortly after the turn of the century, mule-powered teams
do grading work for the Chicago and Eastern Illinois
Railroad near Sidney. The C&EI tracks ran east of town.

PHOTO COURTESY OF
THE CHAMPAIGN COUNTY
HISTORICAL SOCIETY

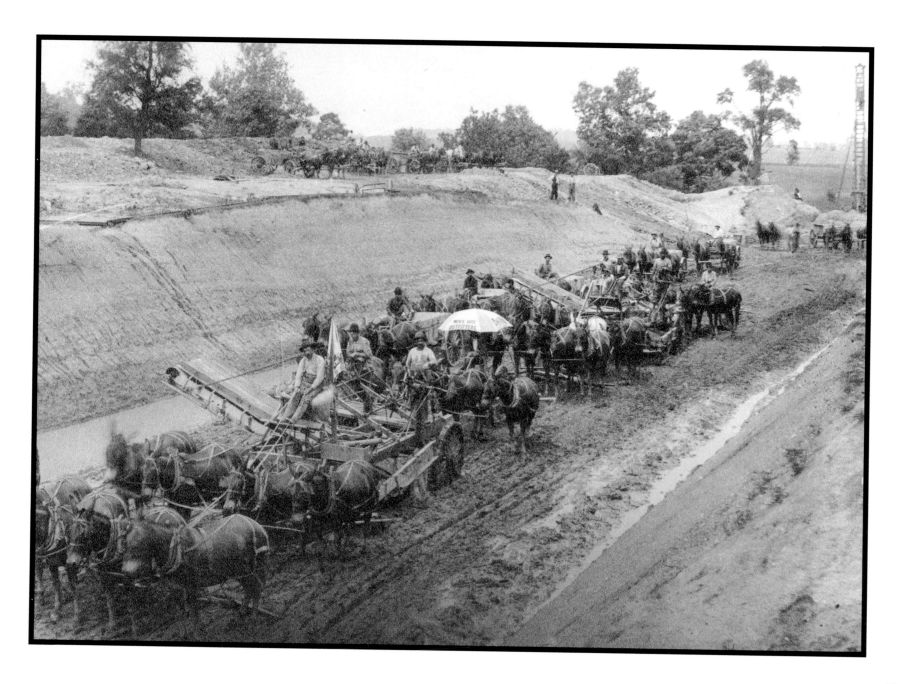

Plowing Through

In 1940, some area farmers were still using horses to plant corn. In contrast, physics professor Donald W. Kerst was inventing the atom smasher that same year at the nearby University of Illinois.

PHOTO COURTESY OF
THE URBANA FREE LIBRARY

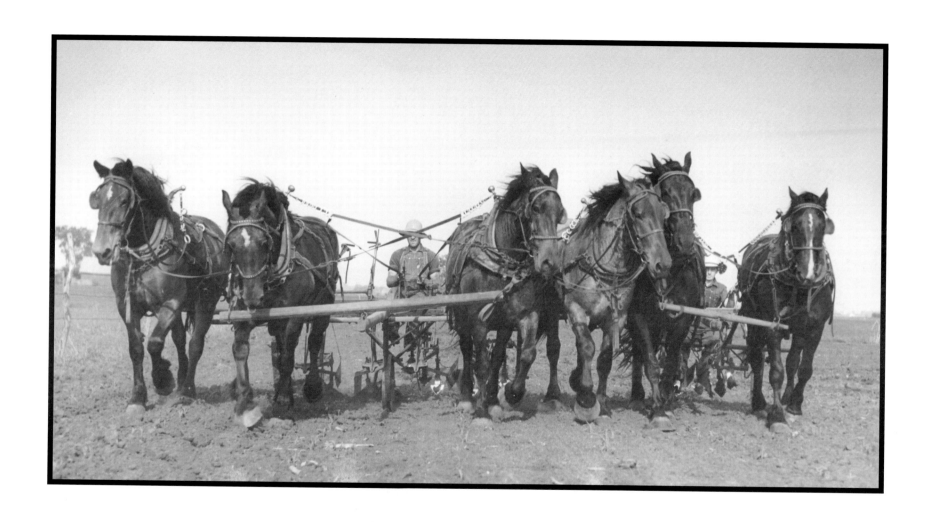

Read All about It!

This photograph, circa 1916, shows the old Gazette
Building, located in Champaign where Hickory Street
and Neil Street once met. The area is now the parking
lot at the corner of Neil and Main.

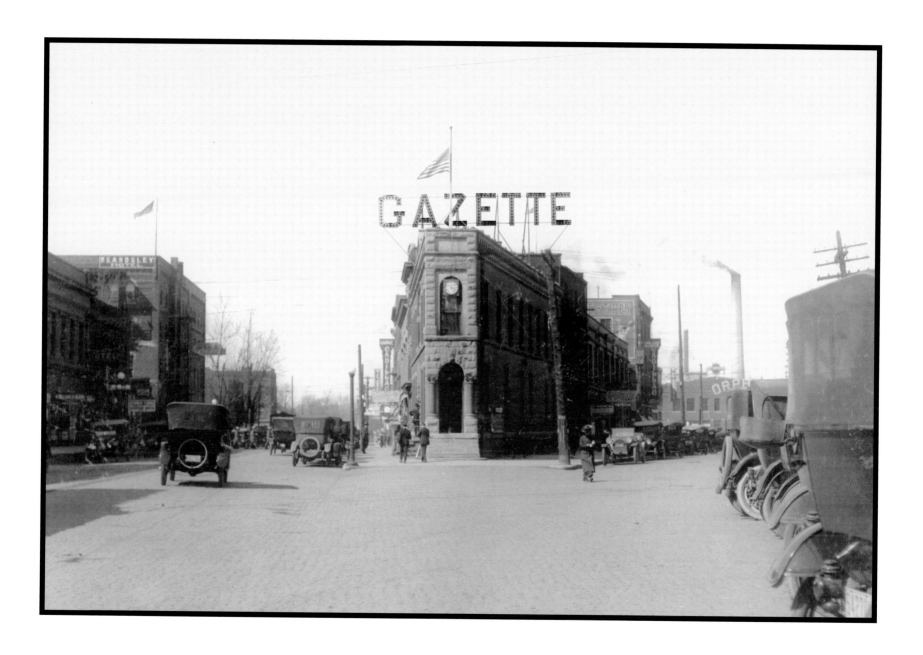

Ray Scott Band

The Ray Scott Band, circa 1916, was made up of leader Ray Scott on the saxophone, Ray Hines on drums, Fay Hines at the piano, Harry Ellis on banjo and Cliff Jordan on violin. Ellis went on to become a prominent Champaign physician.

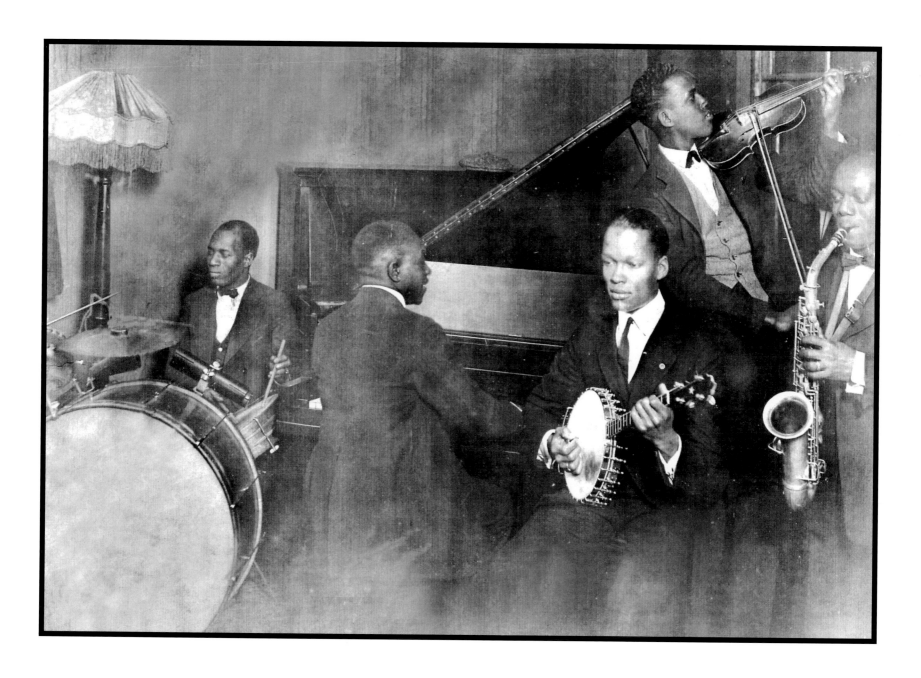

Hay Day

A lone farmer sits atop his horse-drawn hay rake shortly after the turn of the century. Almost 90 years later, 79,000 Illinois farms account for 28 million acres, or approximately 80 percent of the land in the state.

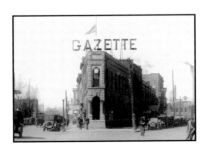

PHOTO COURTESY OF
THE CHAMPAIGN COUNTY
HISTORICAL SOCIETY

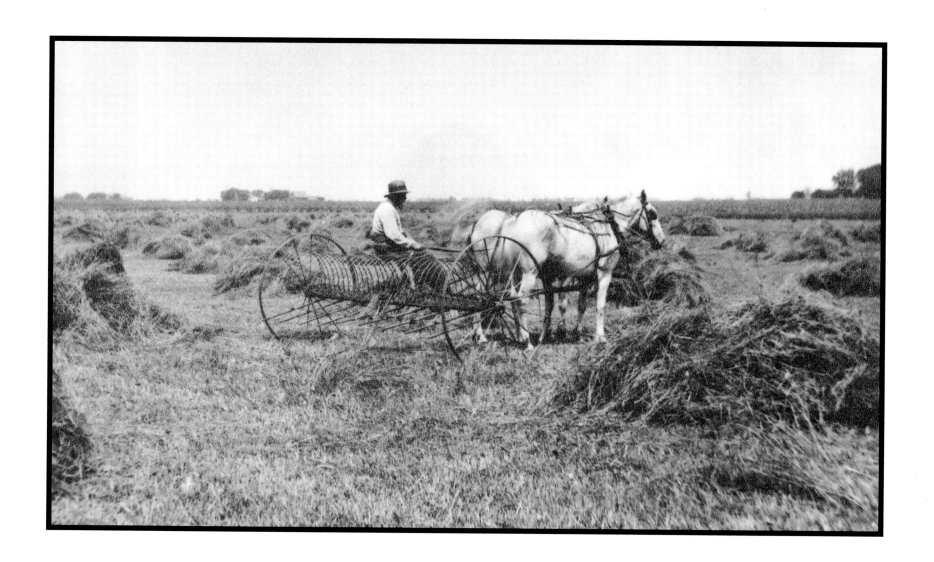

First Car

This photograph, taken in 1903, shows the first automobile in Urbana parked in front of the Amsbary and Sawin store on Main Street. The location, just off Broadway, is now the site of a parking garage.

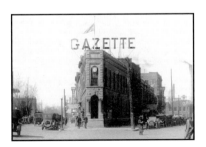

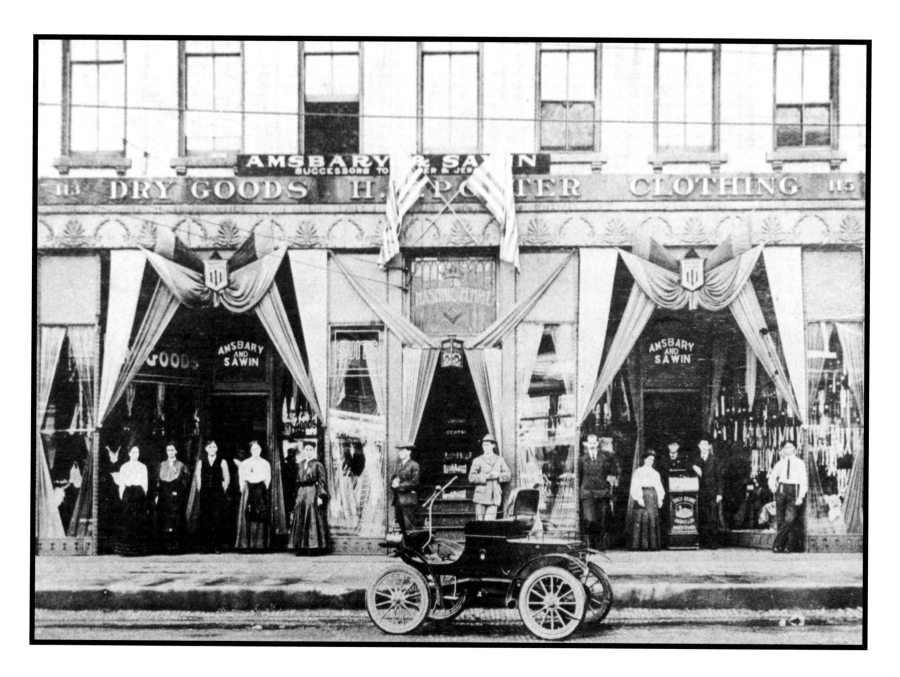

Flying Photogs

In the World War I era, photography and aviation combined to form a new field of interest in the military: aerial photography. Shown here are members of the First Photo Detachment in front of their hut at Chanute Field in Rantoul, June 25, 1918.

PHOTO COURTESY OF
THE OCTAVE CHANUTE
AEROSPACE MUSEUM

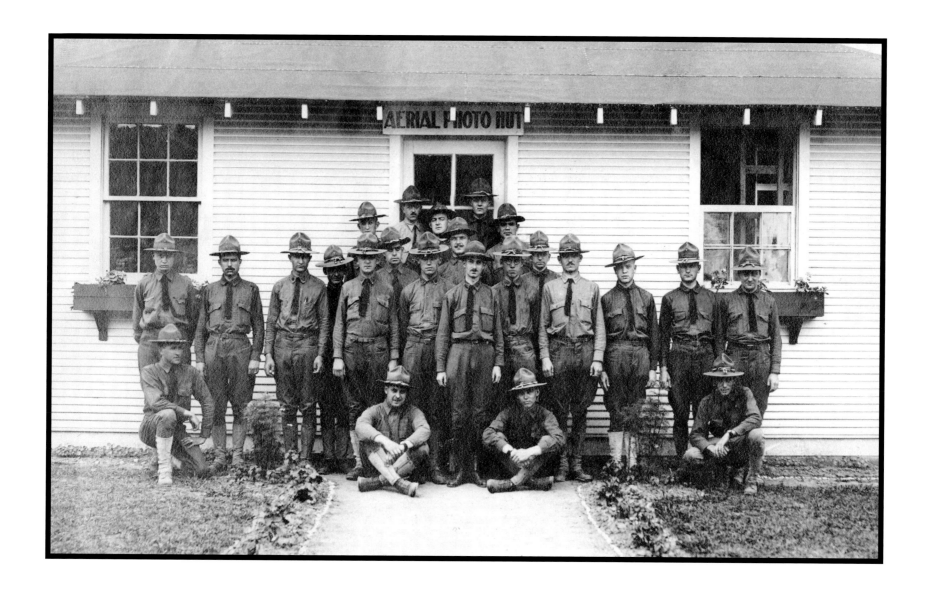

Corner Drugstore

The Knowlton and Bennett drugstore occupied this building, from approximately 1874 until 1926. A delivery wagon waits in front of the store, located at the southeast corner of Main and Race Streets in Urbana.

PHOTO COURTESY OF
THE CHAMPAIGN COUNTY
HISTORICAL SOCIETY

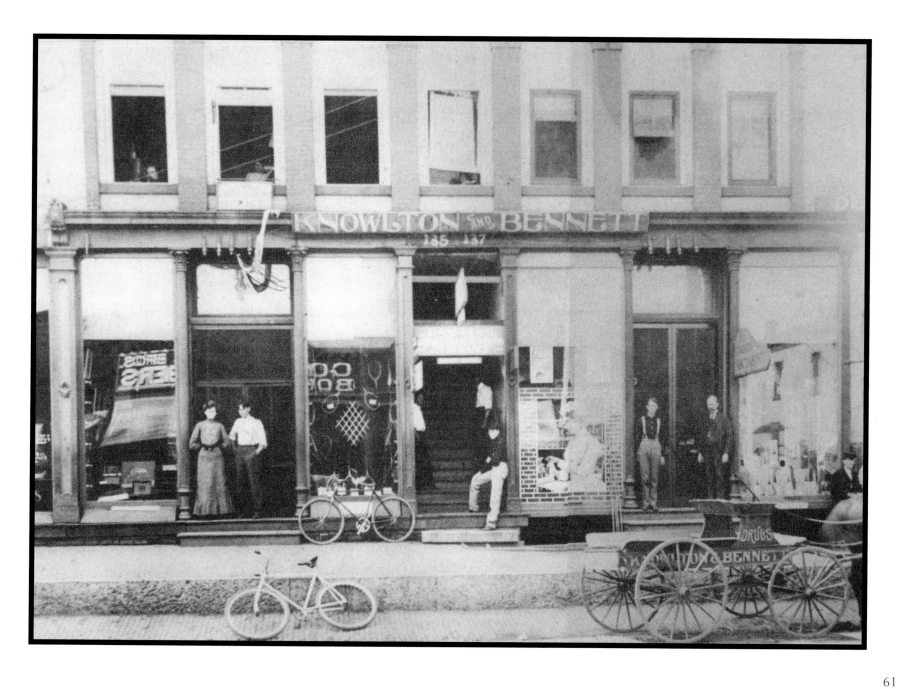

Galloping into History

On October 18, 1924, the day of the official dedication of Memorial Stadium, Harold "Red" Grange became one of the greatest legends of college football. Grange ran for five touchdowns and passed for a sixth as Illinois defeated Michigan 39-14.

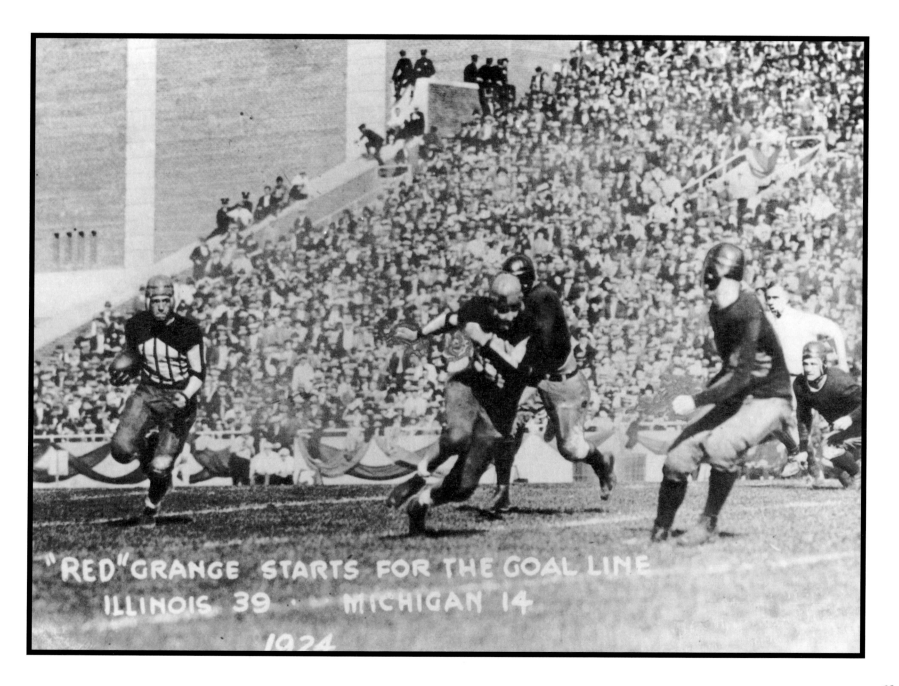

"RED" GRANGE STARTS FOR THE GOAL LINE
ILLINOIS 39 · MICHIGAN 14
1924

Daily Delivery

Delivery trucks wait in front of *The News-Gazette,* known then as the *Champaign Daily News,* in 1919. This building is now the paper's printing plant and distribution headquarters.

PHOTO COURTESY OF
THE CHAMPAIGN COUNTY
HISTORICAL SOCIETY

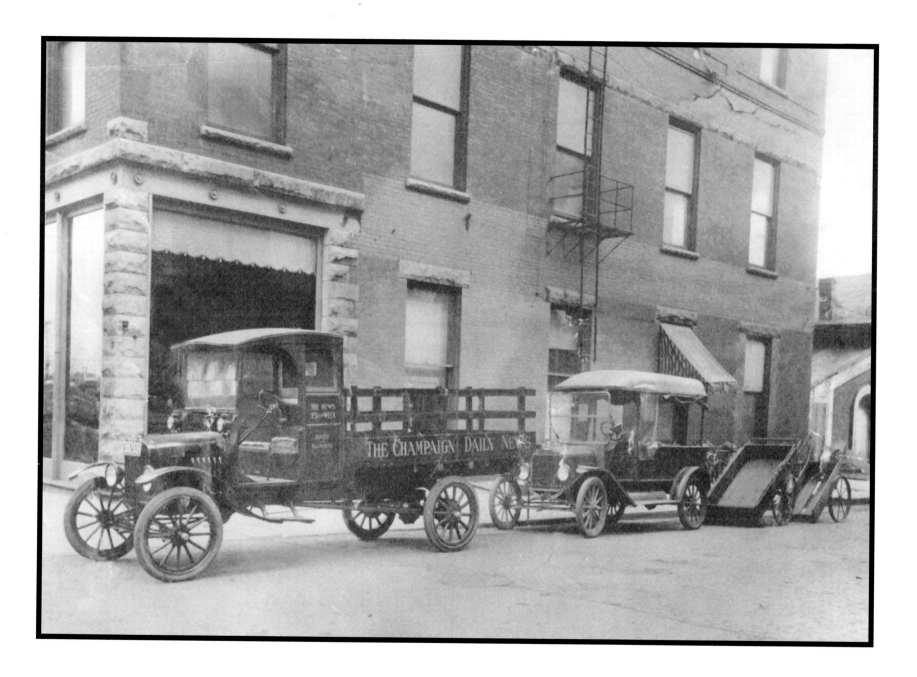

Downtown Mall

From 1975 to 1986, Neil Street was closed to traffic in downtown Champaign to allow for an outdoor pedestrian mall. Here, patrons gather on the street for an apparent open-air auction.

PHOTO COURTESY OF
THE CHAMPAIGN COUNTY
HISTORICAL SOCIETY

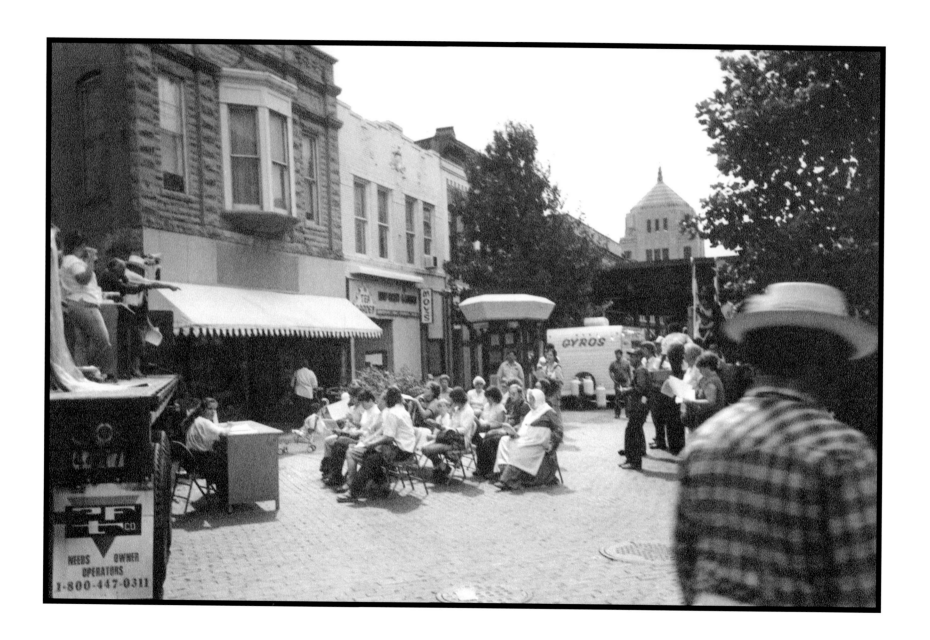

Volunteer Support

Two women at Chanute Air Force Base provide volunteer information for the American National Red Cross in 1952. The Red Cross aids a variety of relief efforts throughout the world.

PHOTO COURTESY OF
THE OCTAVE CHANUTE
AEROSPACE MUSEUM

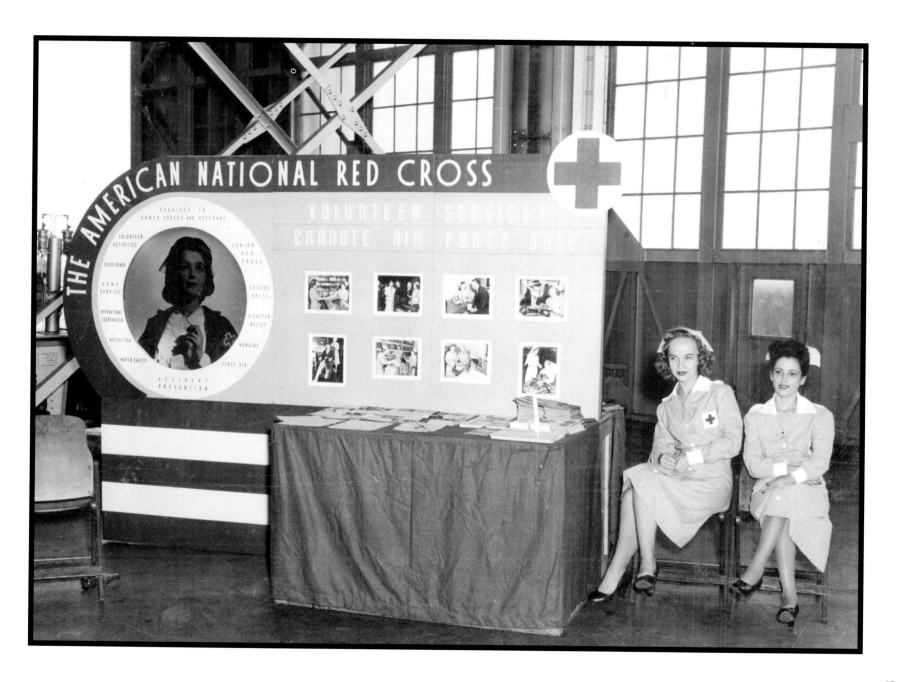

Tornado Aftermath

A tornado passed through Gibson City on March 3,
1961, hitting a 20-block area. Although no serious
injuries were reported, this photograph records some
of the property damage.

PHOTO COURTESY OF
THE URBANA FREE LIBRARY

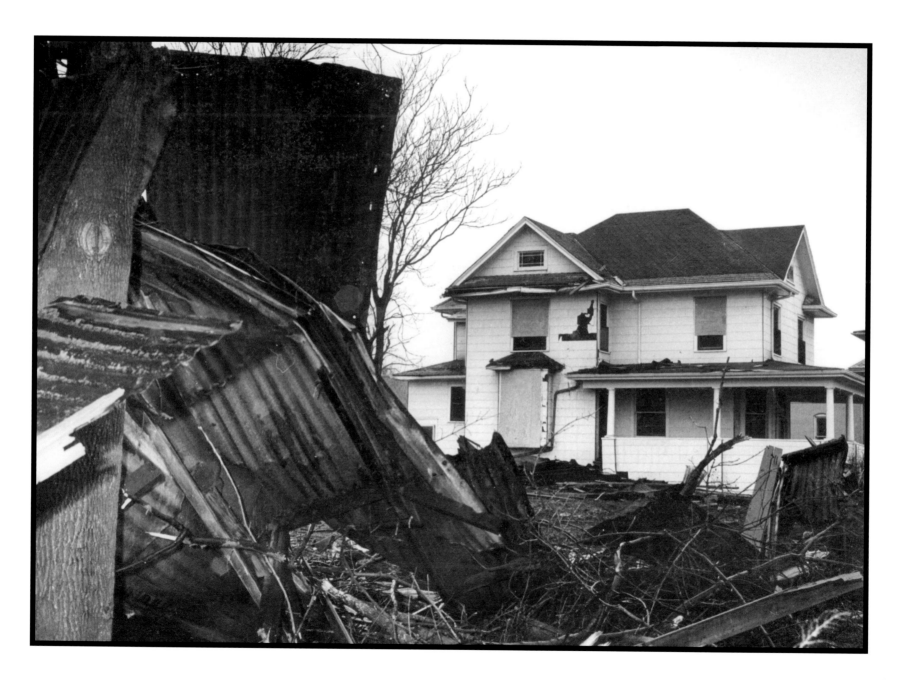

Crystal Lake Lagoon

The Crystal Lake Lagoon attracted several couples on this sunny afternoon, May 22, 1945. The Allies had gained victory in Europe, and Japan would surrender a few months later.

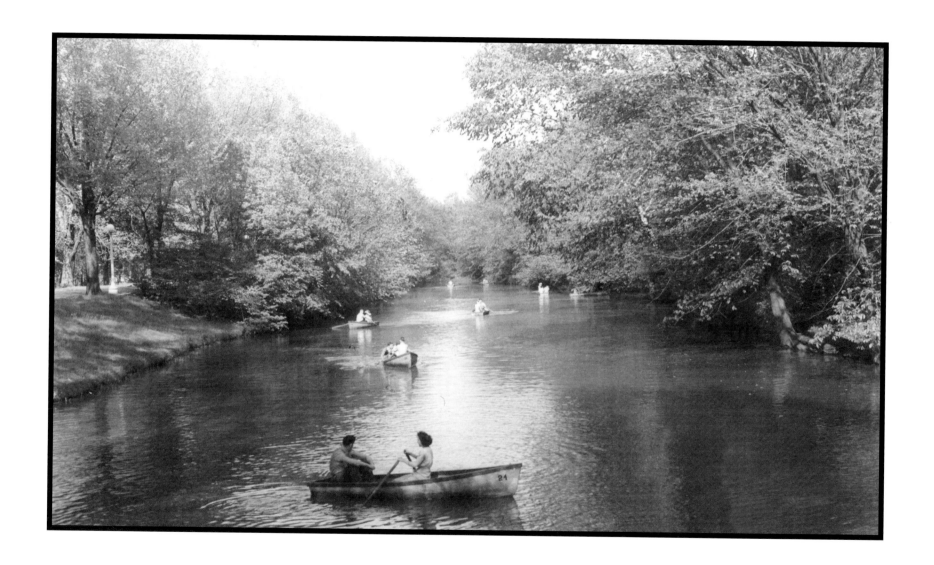

Boypower

These children, who paused long enough to be photographed in 1907, found a way to substitute for the horses that would normally pull this buggy.

PHOTO COURTESY OF
THE CHAMPAIGN COUNTY
HISTORICAL SOCIETY

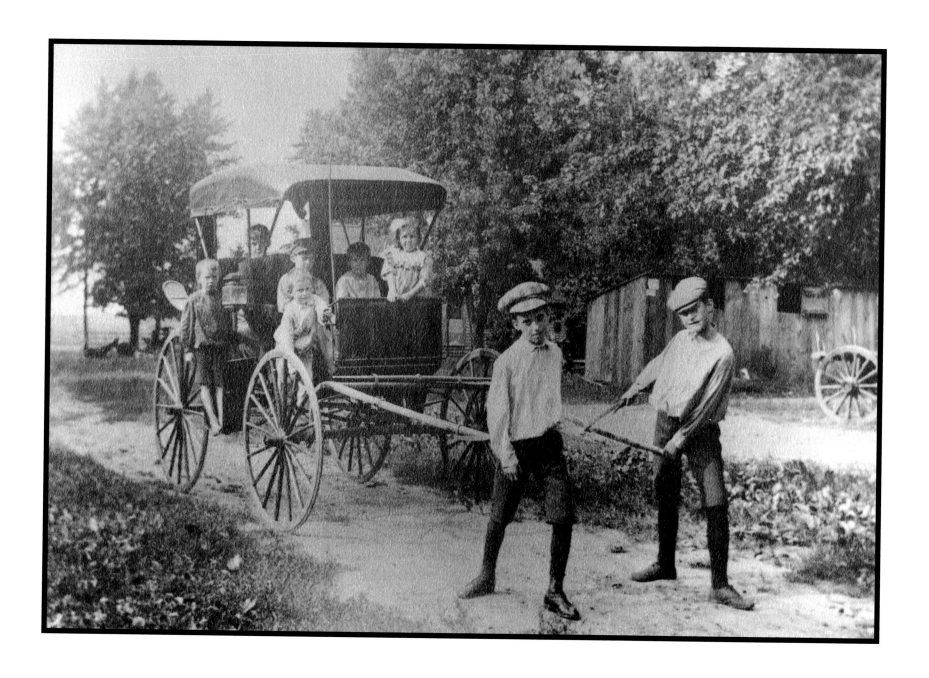

Military Magnitude

Construction on P-3, now known as White Hall, began at Chanute in 1939. Until the opening of the Pentagon in 1942, P-3 was the largest military building in the country.

PHOTO COURTESY OF
THE OCTAVE CHANUTE
AEROSPACE MUSEUM

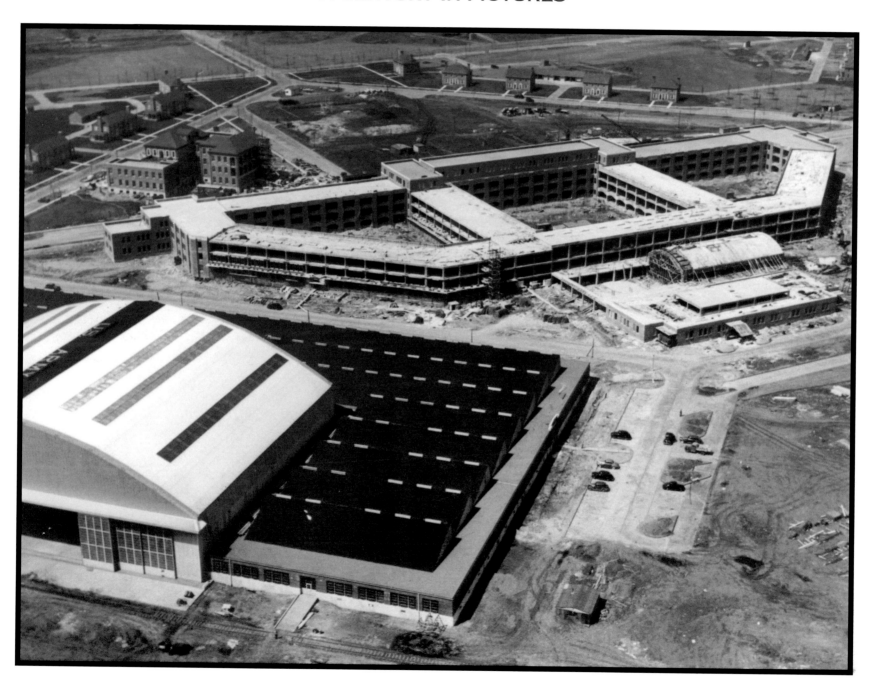

Farmer Royse

Alva Royse cuts grain with a binder pulled by a team of horses on his farm near Monticello, circa 1914. Illinois contains less than four percent of the nation's farms, but accounts for approximately seven percent of total agricultural exports.

PHOTO COURTESY OF
MRS. HELEN MCFEETERS

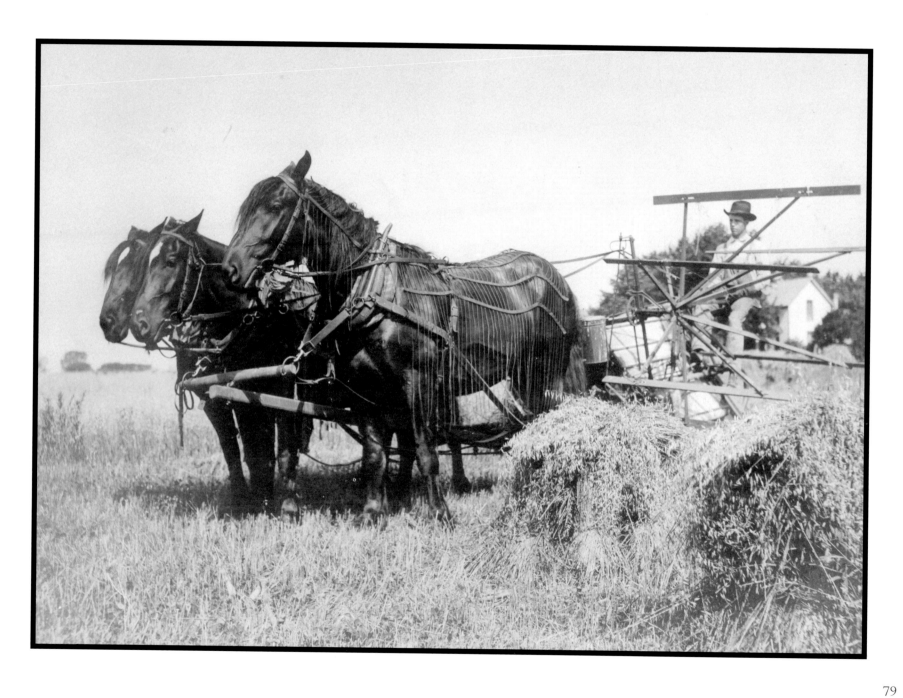

Motoring

These gentlemen, photographed in 1917 or 1918, were out for a drive on West Main Street in Urbana. The uniformed driver may have been on leave from the Army.

PHOTO COURTESY OF
THE URBANA FREE LIBRARY

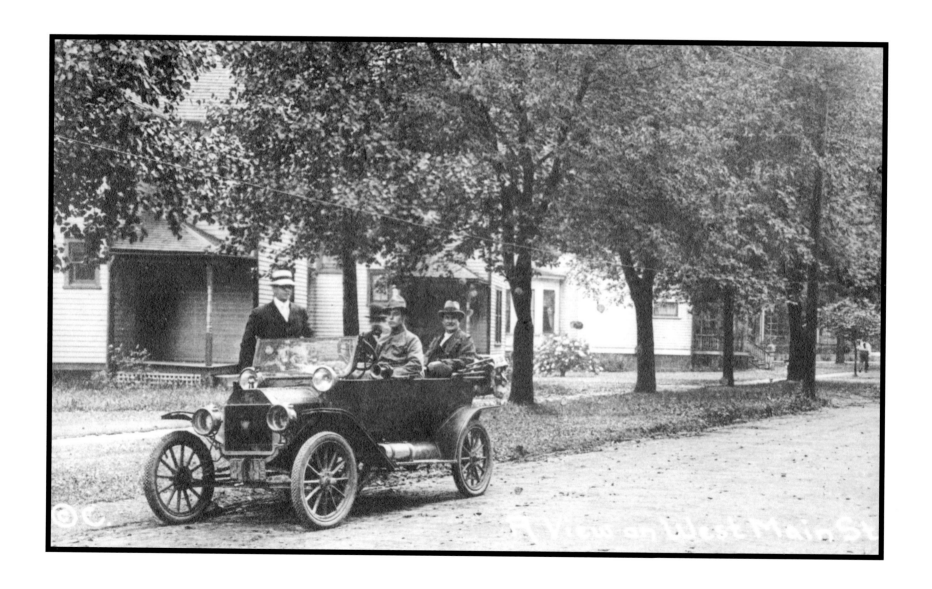

Bull Moose

Theodore Roosevelt, presidential candidate of the Bull Moose Party in 1912, speaks to a crowd of people in the public square in Danville. Roosevelt's campaign split the Republican Party and Democrat Woodrow Wilson was elected president.

PHOTO COURTESY OF THE VERMILION COUNTY MUSEUM SOCIETY COLLECTION

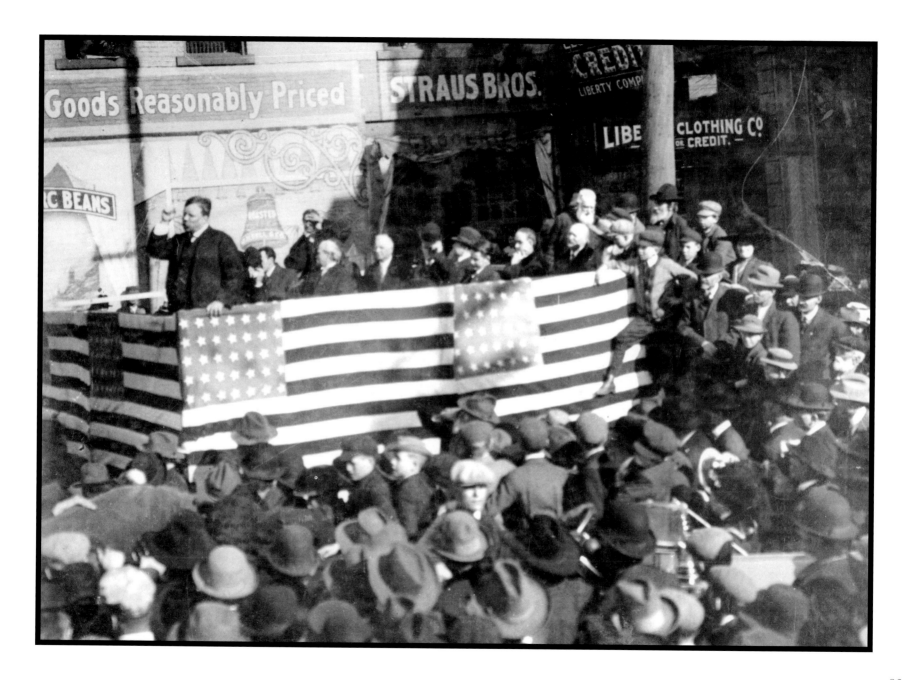

Pete Bridgewater Quintet

Pete Bridgewater, a local African-American music legend, plays bass with the Pete Bridgewater Quintet in this 1963 photo taken at Club 45 in Urbana.

PHOTO COURTESY OF
MR. PETE BRIDGEWATER

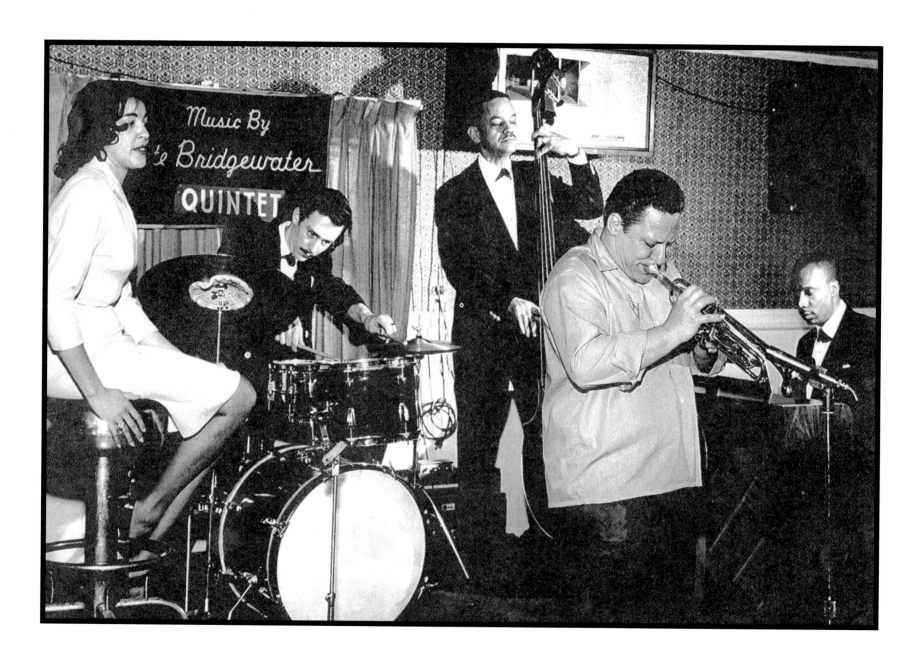

Up, up and Away

Spectators gather to watch a hot air balloon launch in Rantoul in 1902. The city currently hosts the U.S. National Hot Air Balloon Championships.

PHOTO COURTESY OF THE OCTAVE CHANUTE AEROSPACE MUSEUM

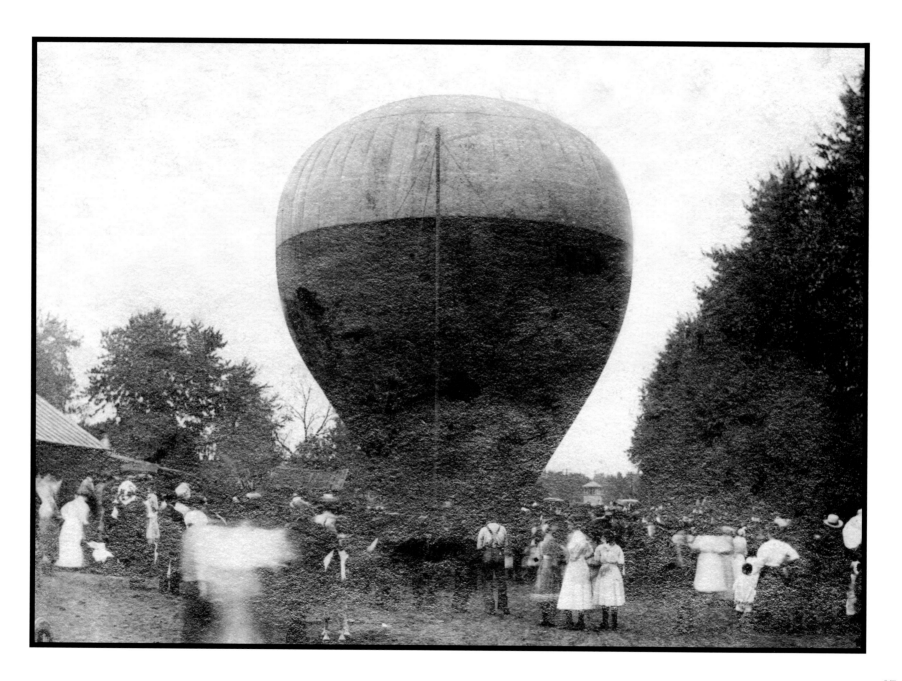

Minors

Brewer's Juvenile Band, 1907, was founded by Mr. Schaede, a German man who lived on Ash Street in Champaign. Band members in this photo include Ray Scott (far left, middle row) and Abraham Music (far left, top row).

PHOTO COURTESY OF MRS. DORIS HOSKINS

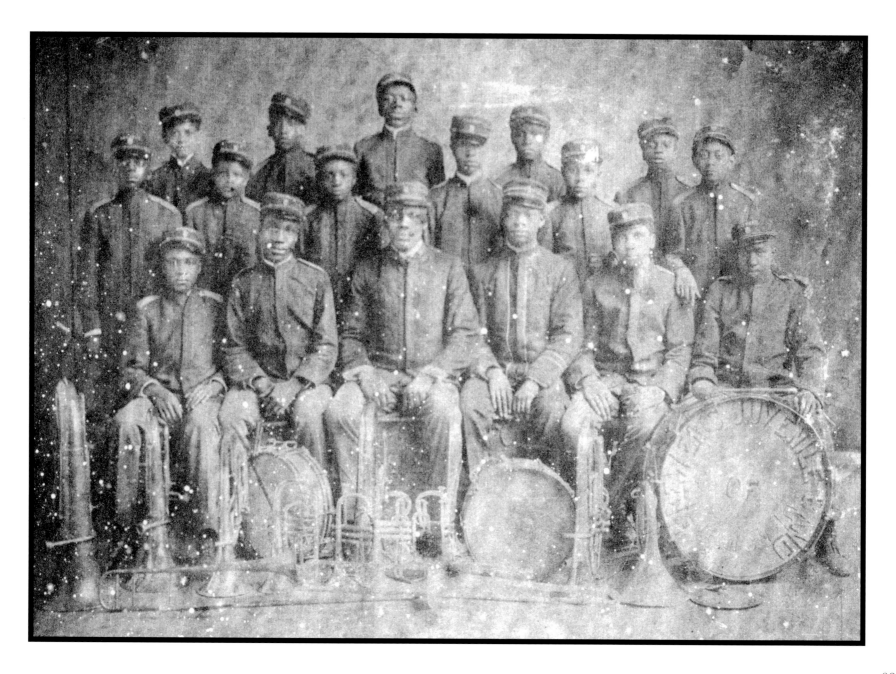

Downtown Rantoul

This photo shows the view on East Sangamon Avenue in Rantoul in 1910. In 1917, Rantoul was chosen to be the site of a government air field in Champaign County.

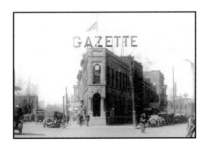

PHOTO COURTESY OF
THE RANTOUL
HISTORICAL SOCIETY

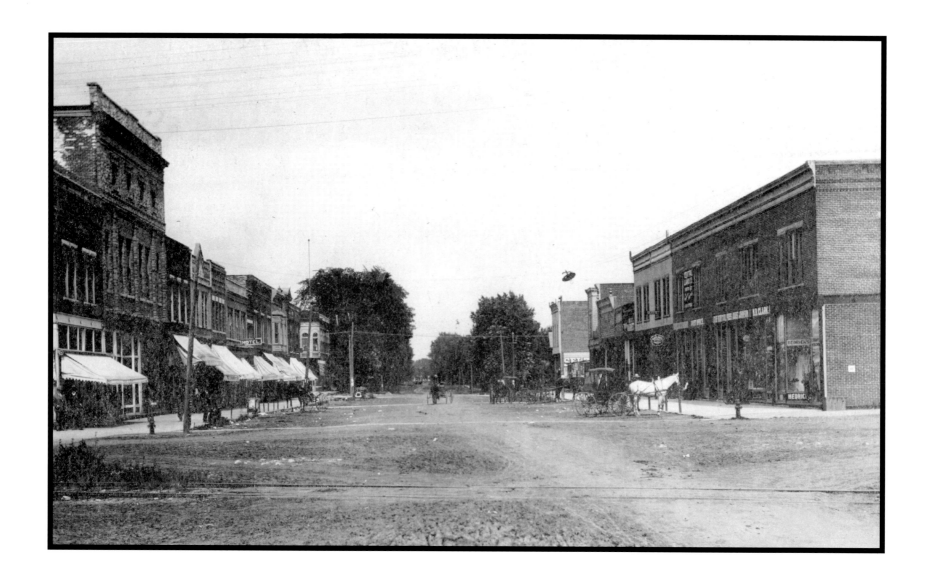

Mrs. Young Votes

Mrs. Mary Jane Young, accompanied by her son, William M. Young, votes in the 1920 presidential election in Newman Township. This was the first year women were allowed to vote, a right granted them by the 19th Amendment.

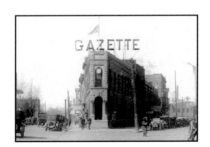

PHOTO COURTESY OF
MR. WILLIAM M. YOUNG

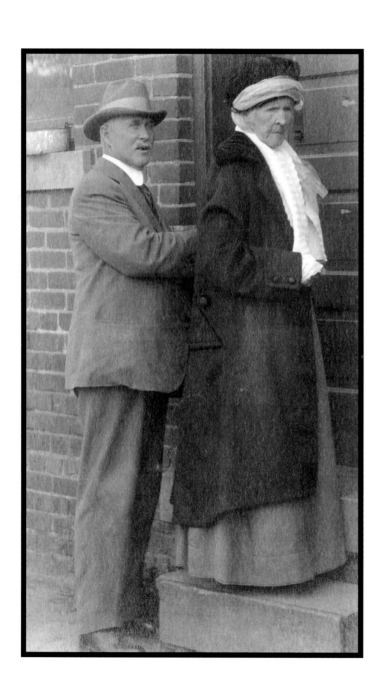

WOMEN'S OFFICIAL BALLOT

CAMARGO TOWNSHIP PRECINCT NO. 2
ELECTION NOVEMBER 2ND, 1920.

C A Hawkins

County Clerk

McCollum vs.
The Board of Education

Vashti Cromwell McCollum, shown with her son James Terry McCollum and her father, Arthur Cromwell, circa 1945, filed a lawsuit objecting to the religious instruction in local schools. In March 1948, the U.S. Supreme Court decided in McCollum's favor.

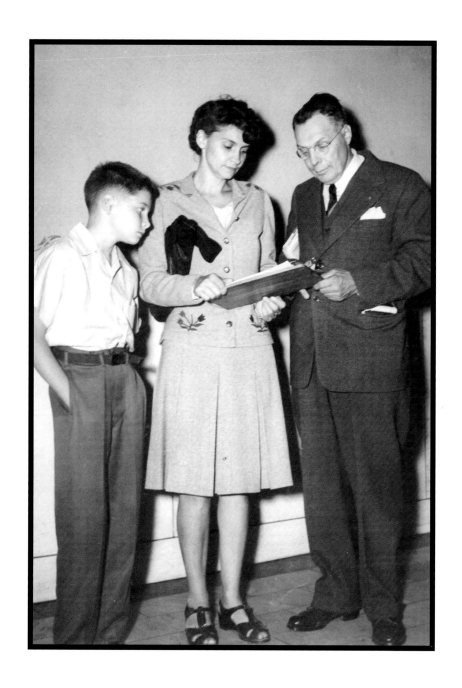

Passover

These men, shown conducting a Passover seder at Chanute
Air Force Base, did not let their military duty prevent them
from fulfilling their religious obligations.

PHOTO COURTESY OF
THE OCTAVE CHANUTE
AEROSPACE MUSEUM

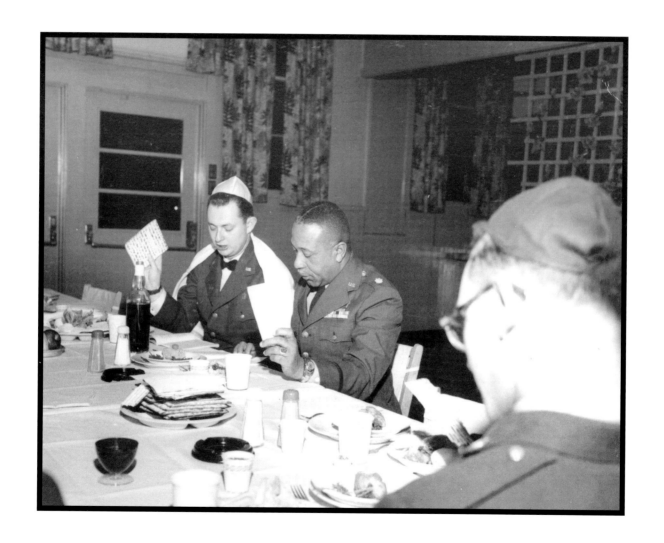

Landmark

The Dale Building at Vermilion and North streets in Danville
remains much the same today above the first floor as it was
in this photo from the first decade of the century.

PHOTO COURTESY OF
THE VERMILION COUNTY
MUSEUM SOCIETY
COLLECTION

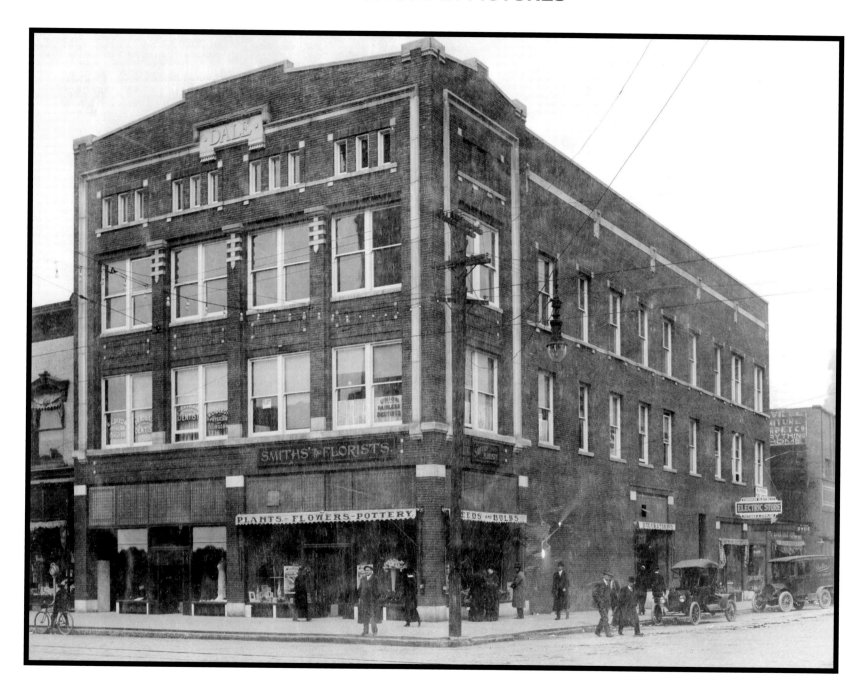

School Days

Members of the 1954-55 first-grade class at Gregory School
in Champaign smile for the camera in this class photo.
The school, built in 1905, closed in 1969 and was converted
to apartments in 1991.

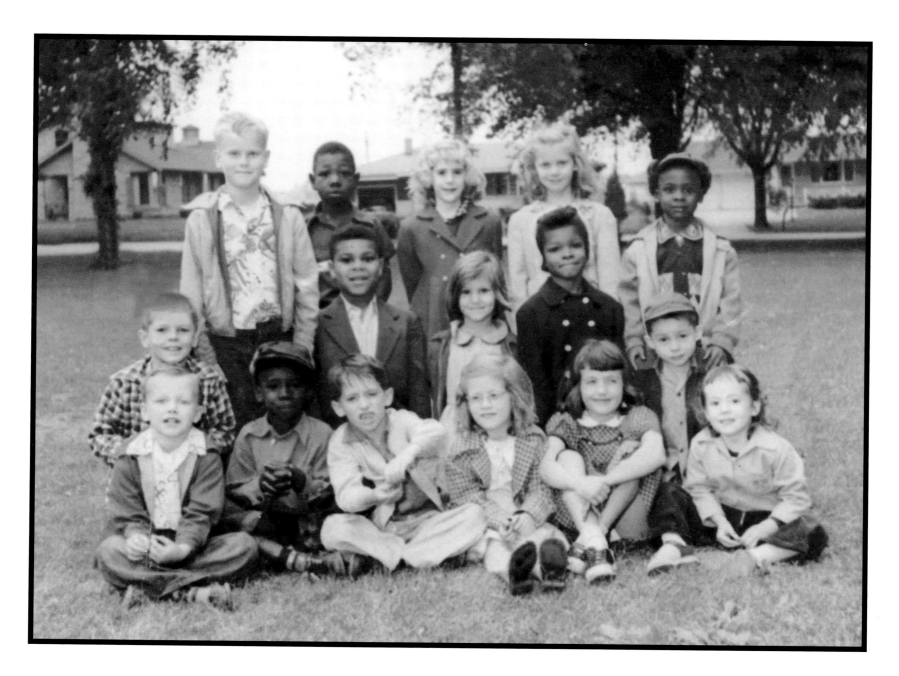

Lucky Lindy

Col. Charles Lindbergh (second from right) tours Chanute Air Force Base with, from left, Lt. Bill Sloan, Maj. Al Kincaid, Capt. Norme Frost and Maj. Harry Johnson on July 7, 1939. In 1924, Lindbergh came to Chanute for flight qualification testing.

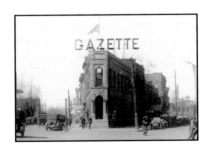

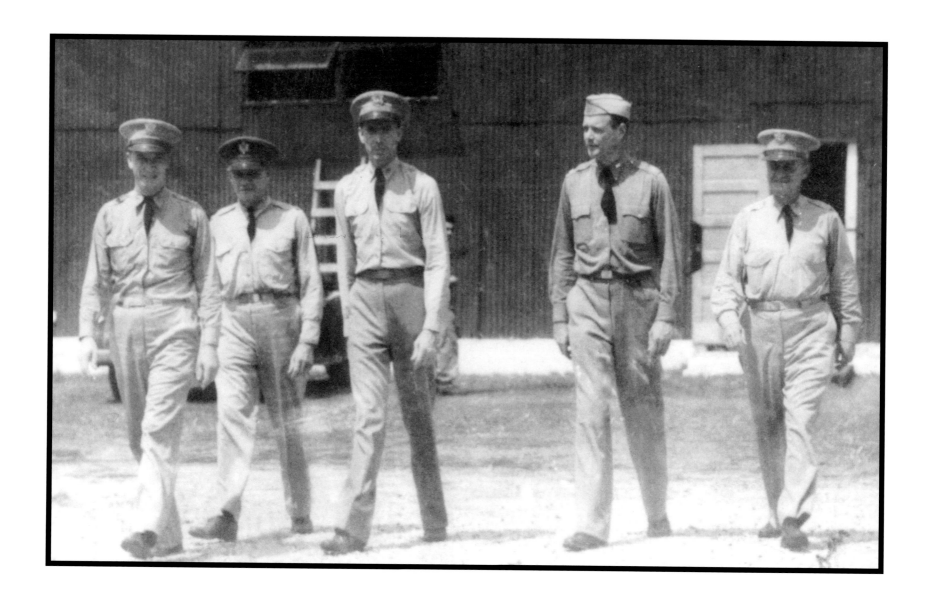

Doughnut Dollies

The "Doughnut Dollies" of the USO offered free refreshments to traveling military personnel at the Chicago and Eastern Illinois Railroad depot in Danville during World War II.

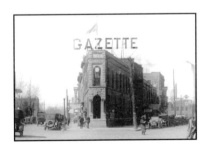

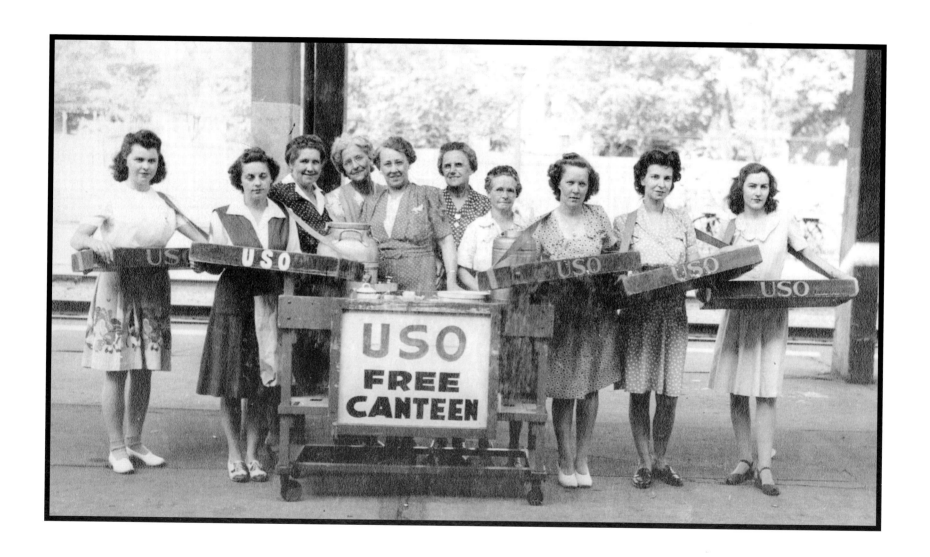

Home, Sweet Home

This woman was photographed in front of her home at
302 ½ East Main Street in Urbana in approximately 1908.
The house was torn down around 1952.

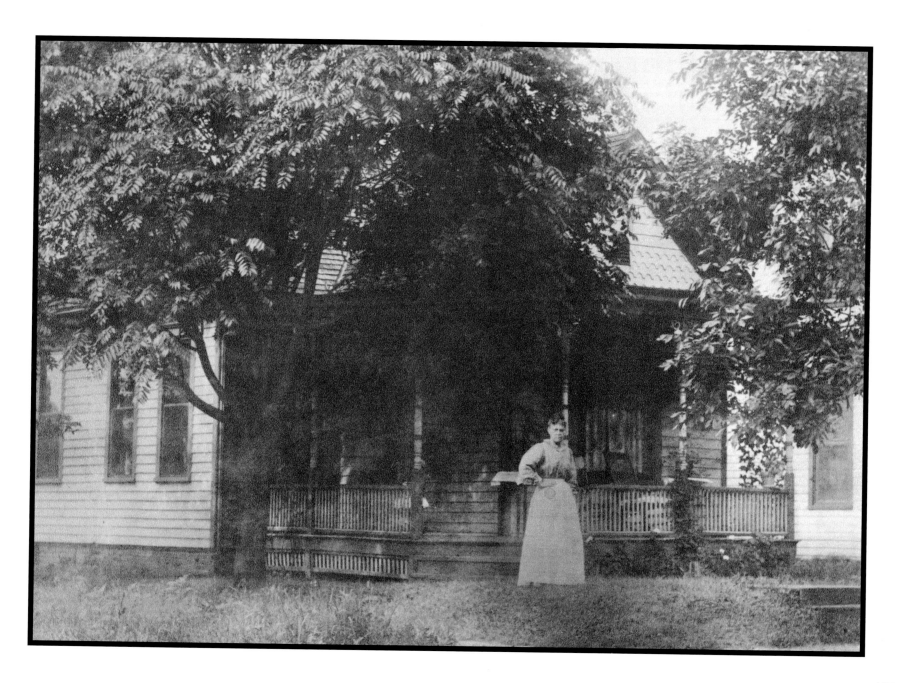

Unfortunate Accident

With the growing popularity of automobiles came the growing risk of automobile accidents. This wreck occurred outside of Champaign in 1919.

PHOTO COURTESY OF
THE CHAMPAIGN COUNTY
HISTORICAL SOCIETY

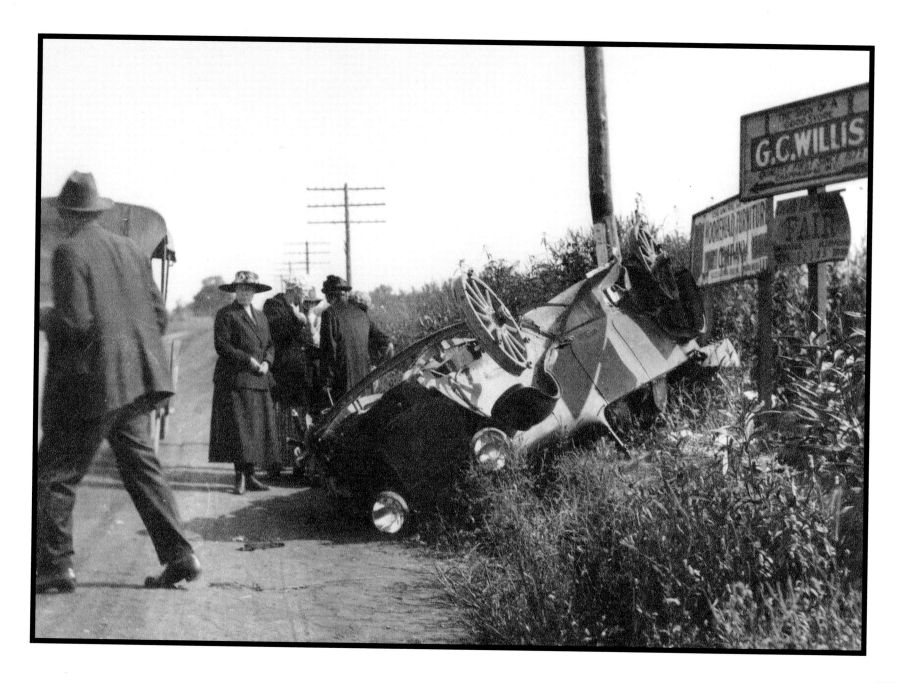

Victory Parade

Battery A of the 149th Artillery returns home to a parade in Danville in 1919 after serving in France during World War I.

PHOTO COURTESY OF
THE VERMILION COUNTY
MUSEUM SOCIETY
COLLECTION

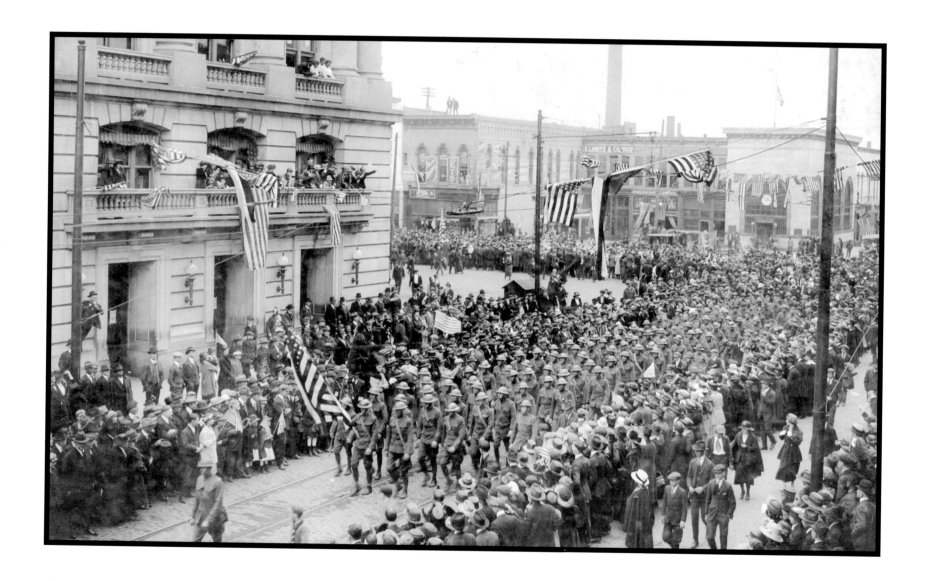

Tuskegee Airmen

On March 19, 1941, the 99th Pursuit Squadron was activated at Chanute. In 1942, the squadron moved to Tuskegee Air Base in Alabama, where its members became known as the "Tuskegee Airmen." Chanute trained the first 278 African-American airmen in United States history.

PHOTO COURTESY OF
THE OCTAVE CHANUTE
AEROSPACE MUSEUM

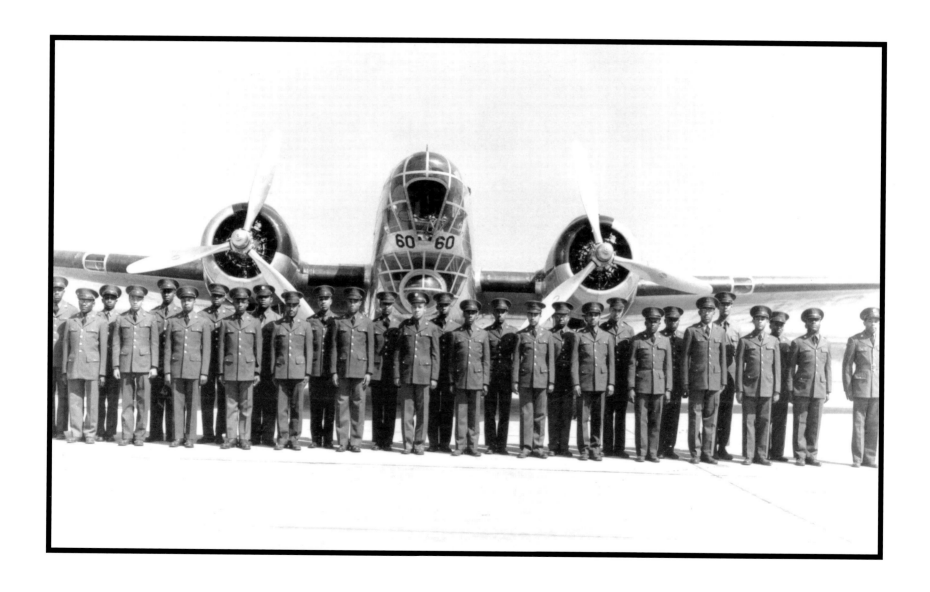

May We Help You?

Kirkpatrick's Department Store, at 115 South Race Street in
Urbana, offered a variety of merchandise. These customers
and employees were photographed in the early 1900s.

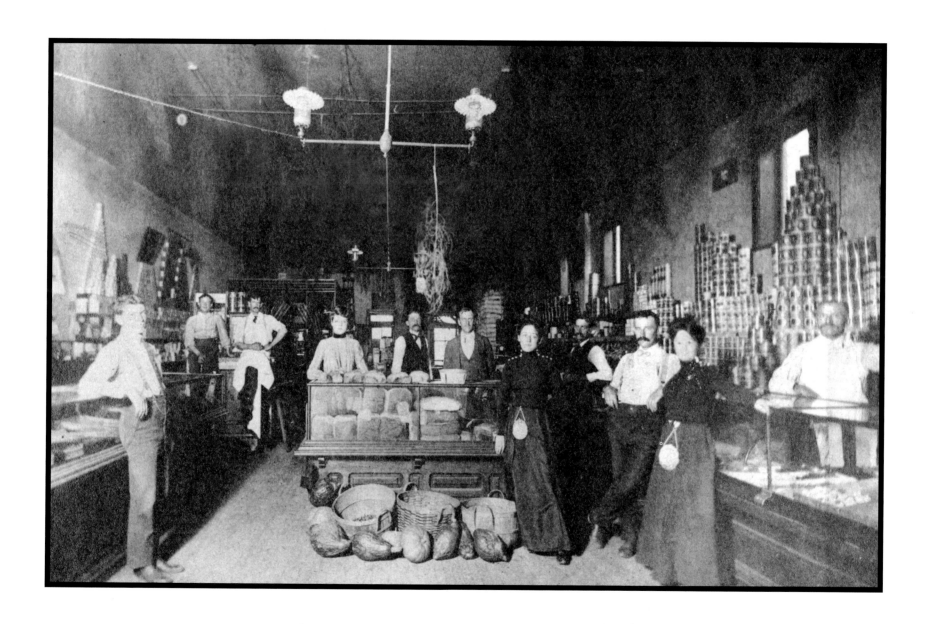

Mobile Home

When this photo was taken in 1940, this structure was the last original log cabin in Champaign County. Built in Sadorus in 1870, the cabin was moved to the Champaign County Fairgrounds and then back to Sadorus before being torn down and burned in 1941.

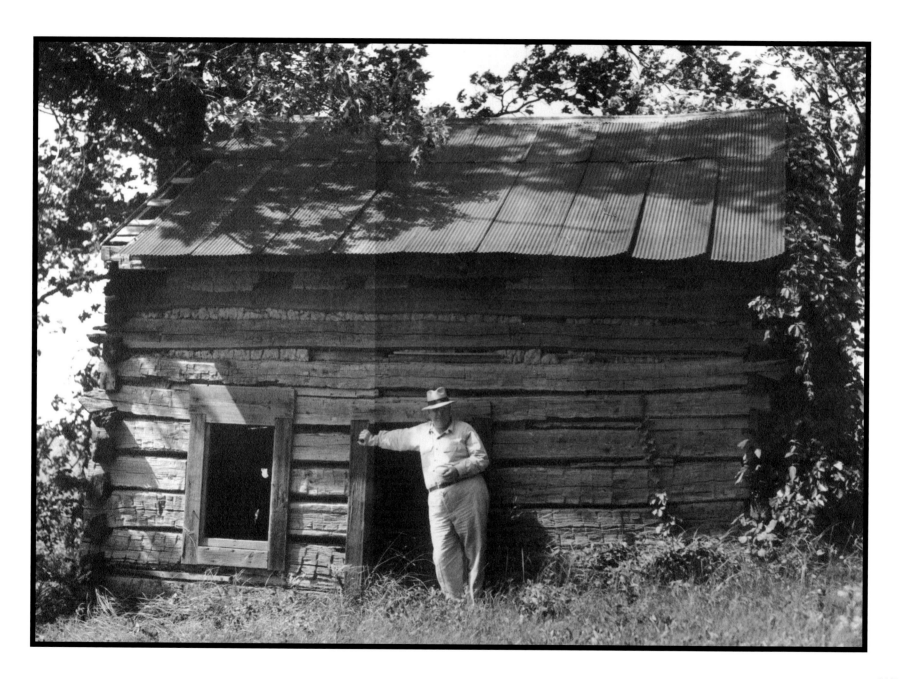

Making a Difference

Make a Difference Day donors and volunteers gather for a photo in the Parkland College Gym on November 15, 1992. The community's collection of toiletries and other essentials for the homeless was one of the largest in the country.

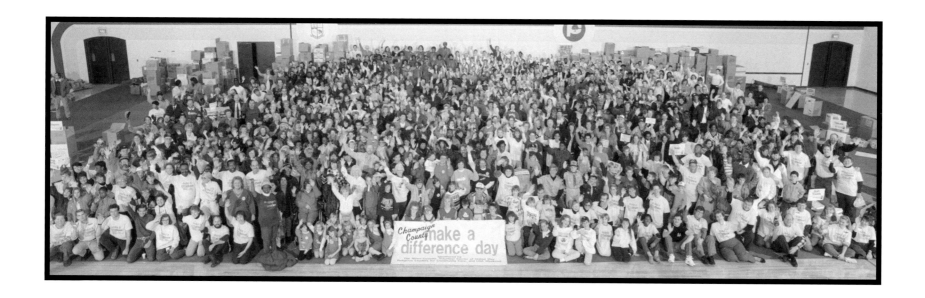

Burned Out

The Flat Iron Building in Urbana burned on the evening of
March 11, 1948, causing an estimated $500,000 in damages.
Although no final determination was made, inspectors believed
the fire was caused by an electrical short or malfunction.

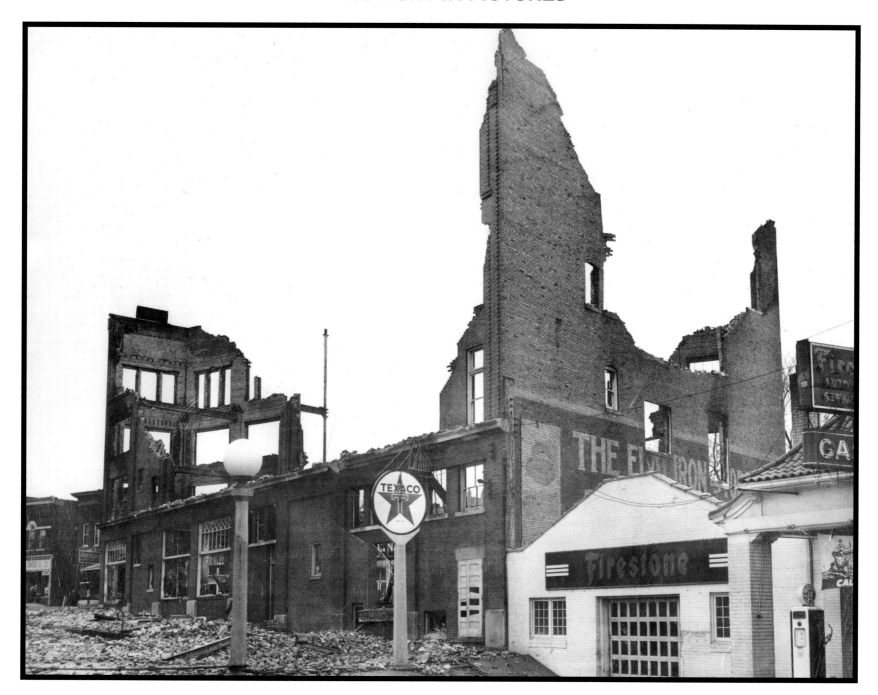

Strip Mining

A stripping shovel uncovers coal at United Electric Mine No. 1, four miles west of Danville, in 1922. The site is now part of Kickapoo State Park.

PHOTO COURTESY OF
THE VERMILION COUNTY
MUSEUM SOCIETY
COLLECTION

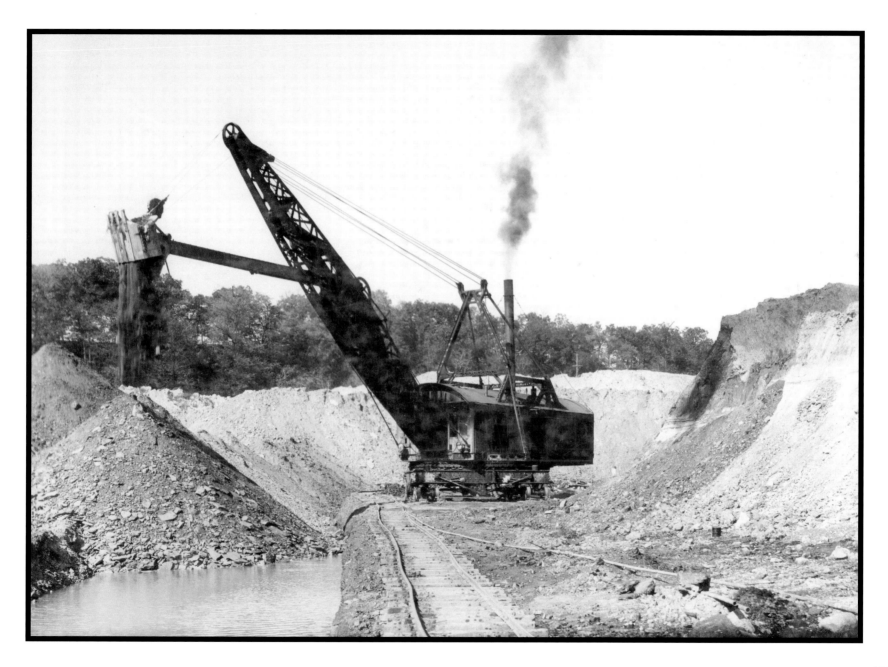

Champaign's Favorite Speeder

Champaign native Bonnie Blair is honored at *The News-Gazette* for winning a gold and a bronze medal for speed skating at the 1988 Winter Olympic Games in Calgary. She went on to win two gold medals in Albertville in 1992 and two more in Lillehammer in 1994.

PHOTO COURTESY OF
THE NEWS-GAZETTE

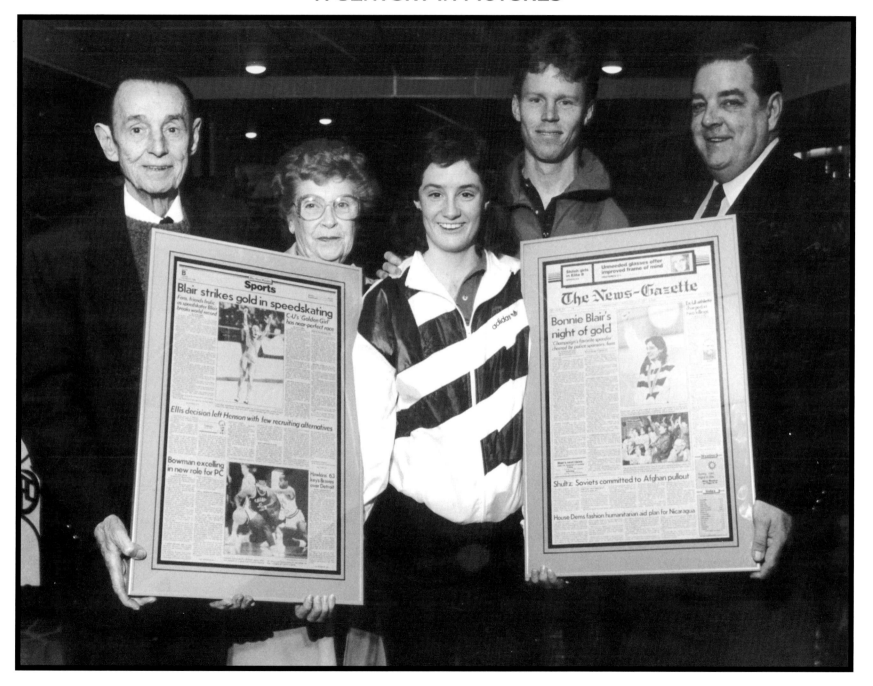

First Lady

Joan Severns, the first and only female mayor of
Champaign, takes her oath of office. Severns served as
mayor from 1979 to 1983.

PHOTO COURTESY OF
THE NEWS-GAZETTE

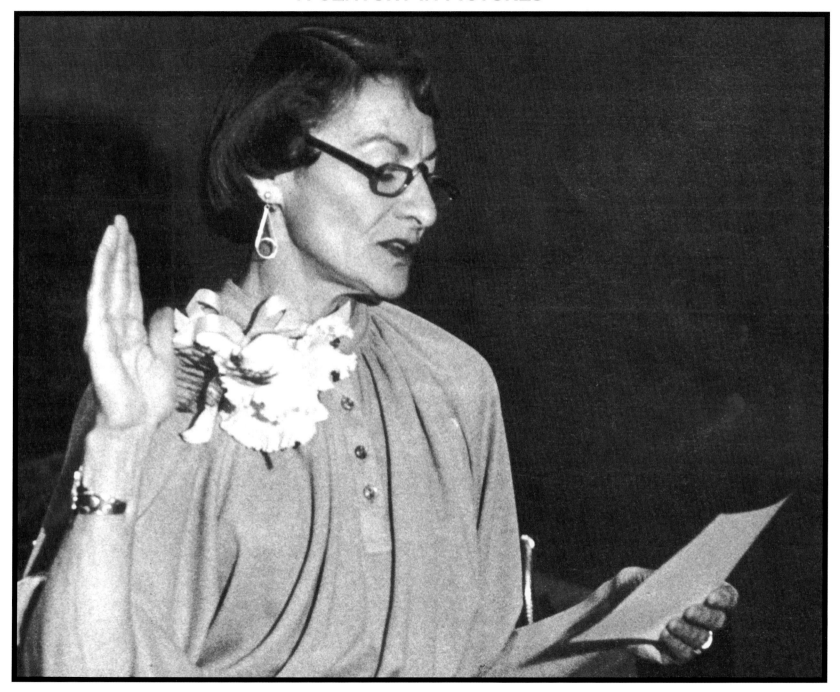

The Lyric Theatre

The Lyric Theatre was built in 1907 on the site of an old car and mule barn at approximately 150 North Vermilion Street. The building later became the Palace Theatre and the location is now the site of Palace Park.

PHOTO COURTESY OF THE VERMILION COUNTY MUSEUM SOCIETY COLLECTION

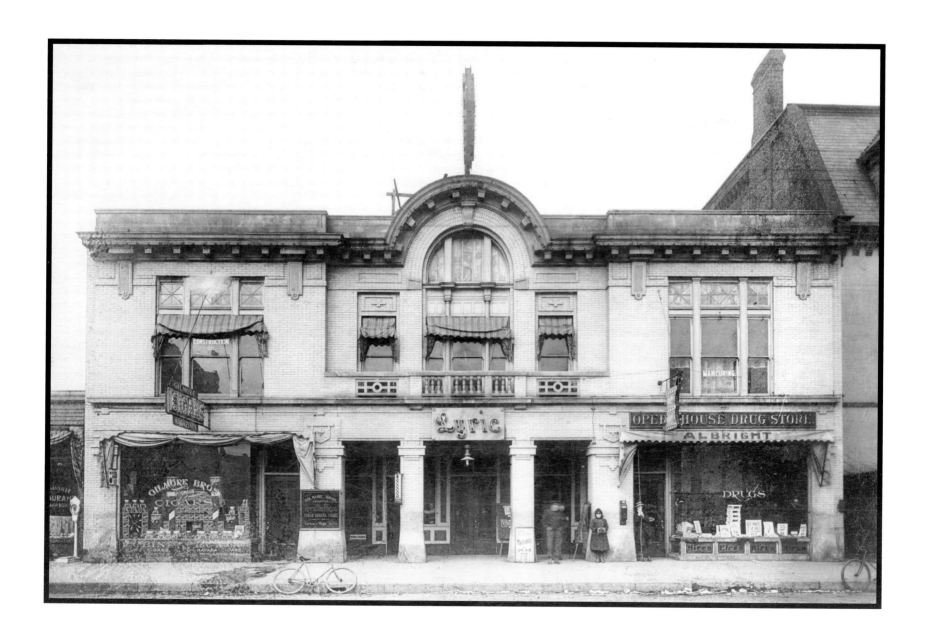

Fixin' It

From 1920 to 1938, Chanute Field was the only training field for the Army Air Corps. Classes included everything from airplane maintenance to parachute rigging. Here, mechanics overhaul an airplane engine.

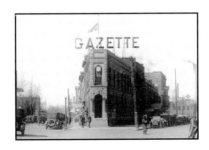

PHOTO COURTESY OF
THE OCTAVE CHANUTE
AEROSPACE MUSEUM

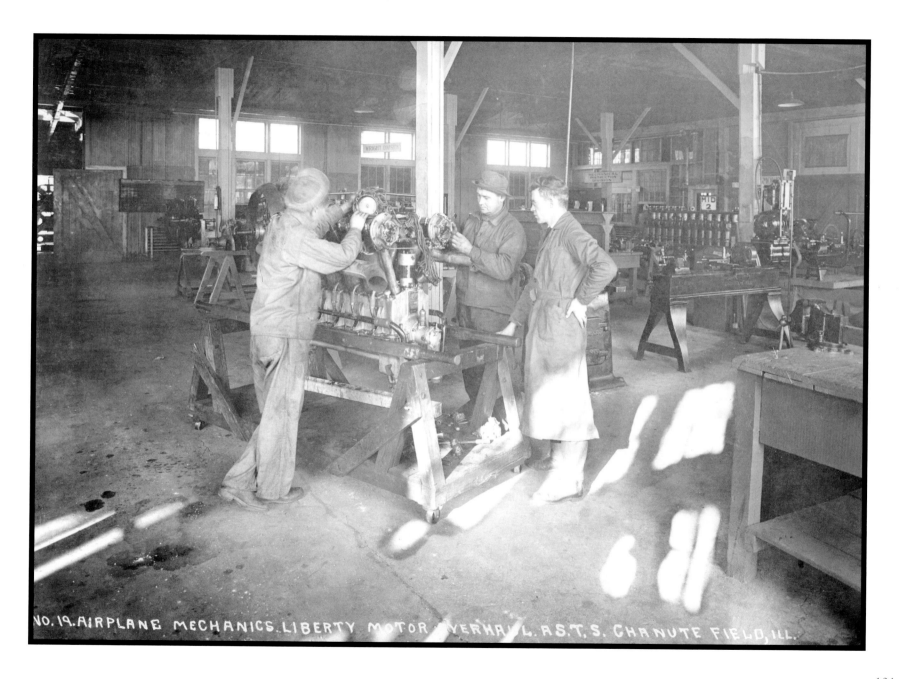

NO. 19. AIRPLANE MECHANICS, LIBERTY MOTOR OVERHAUL, A.S.T.S. CHANUTE FIELD, ILL.

Student Demonstration

Three different student groups demonstrate on the University of Illinois campus in 1983. On the left, students show their support for President Reagan's intervention in Grenada, while the students on the right protest the same action. In the background, students from El Salvador protest American involvement in their country.

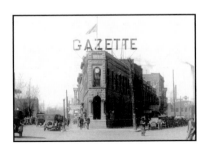

PHOTO COURTESY OF
THE NEWS-GAZETTE

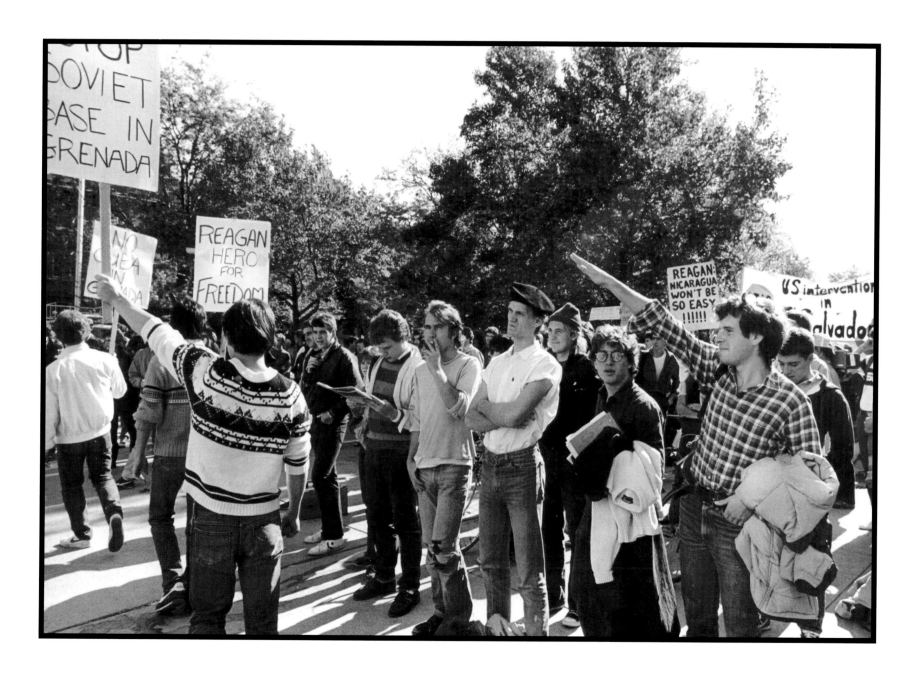

President Taft

William Howard Taft addresses a crowd gathered in Monticello. Taft, our 27th president, visited the city while campaigning for the office in 1908.

PHOTO COURTESY OF
MRS. HELEN McFEETERS

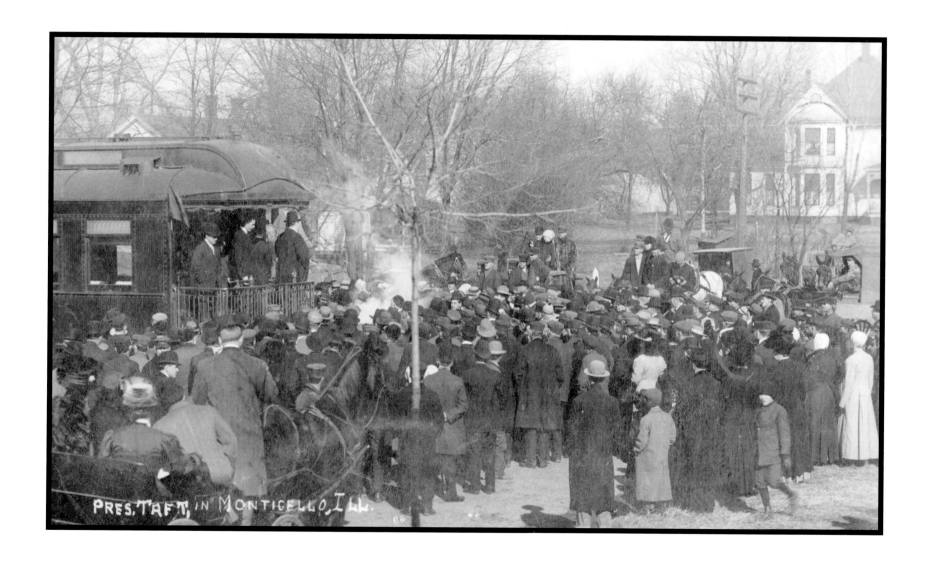

PRES. TAFT IN MONTICELLO, ILL.

Melody Maids

The Melody Maids toured Air Force bases during the
Christmas season to bring some holiday cheer to the troops.
Here, they visit the orthopedic ward at the Chanute Air
Force Base hospital.

PHOTO COURTESY OF
THE OCTAVE CHANUTE
AEROSPACE MUSEUM

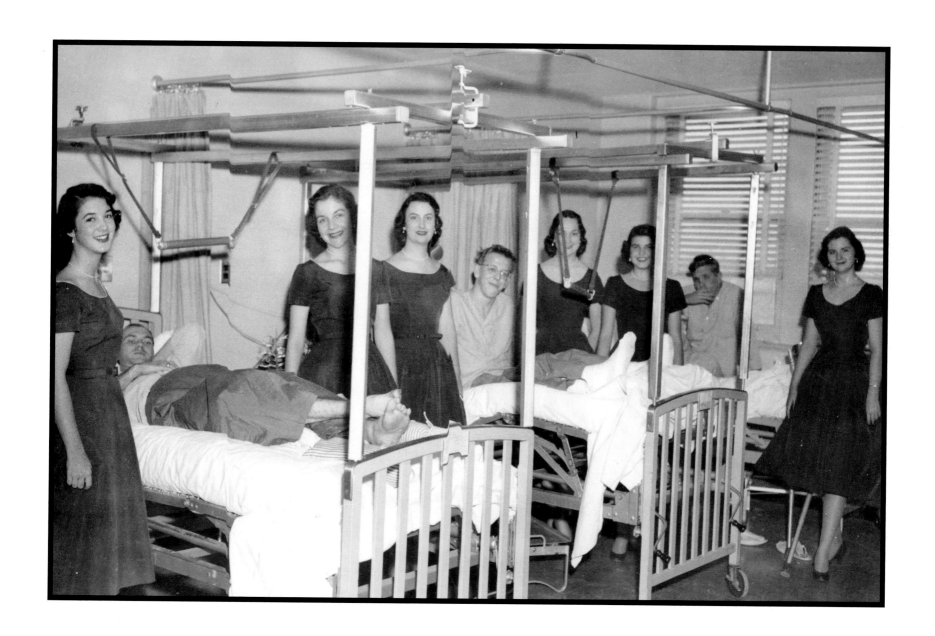

Police Chiefs Race for Cure

Three local police chiefs, Paul Dollins (left), from the University of Illinois, Donald Long (center) of Urbana, and William Dye of Champaign, prepare for the American Cancer Society Bikeathon in May 1976.

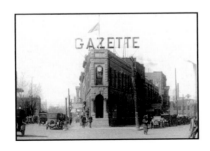

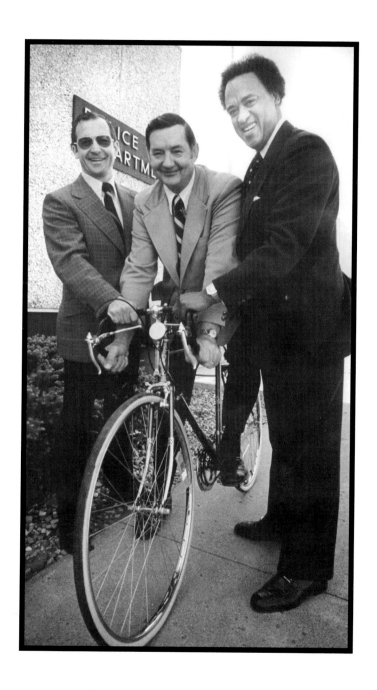

Vriner's

Vriner's was opened in downtown Champaign in 1898 by Peter George Vriner. This photo of Sam "Tyke" Vriner (center) and his sons Pete (left) and Willie shows the confectionery's interior in 1985. Today, the Vriner's building houses a restaurant.

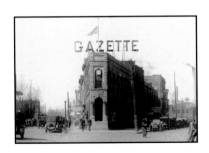

PHOTO COURTESY OF THE CHAMPAIGN COUNTY HISTORICAL SOCIETY

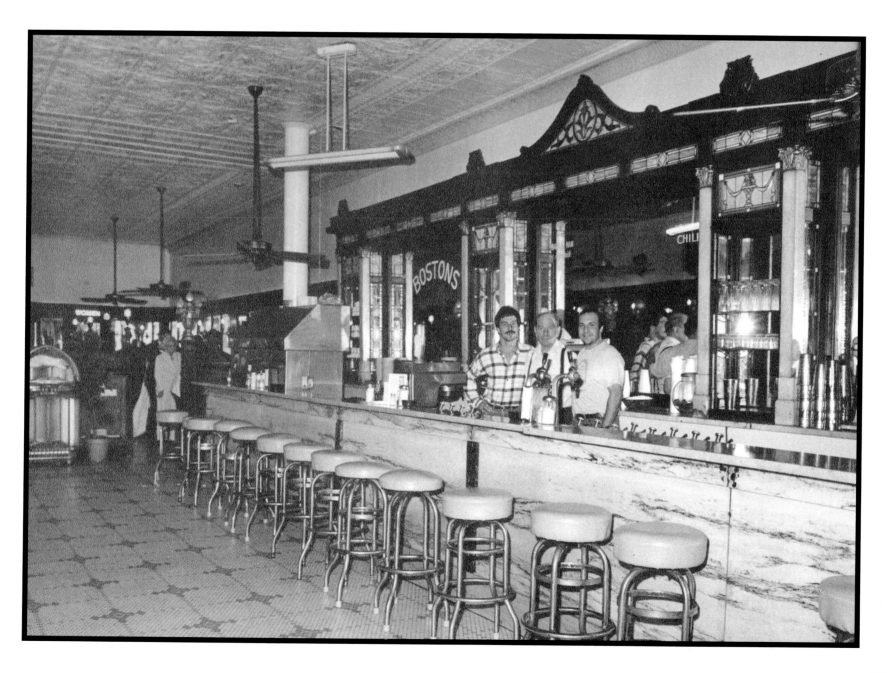

Candidate Scott

Anna Wall Scott attaches a campaign sign to the Democratic Tent at the Champaign County Fair in July 1976. Scott was the Democratic candidate for Congress from the 21st Congressional District.

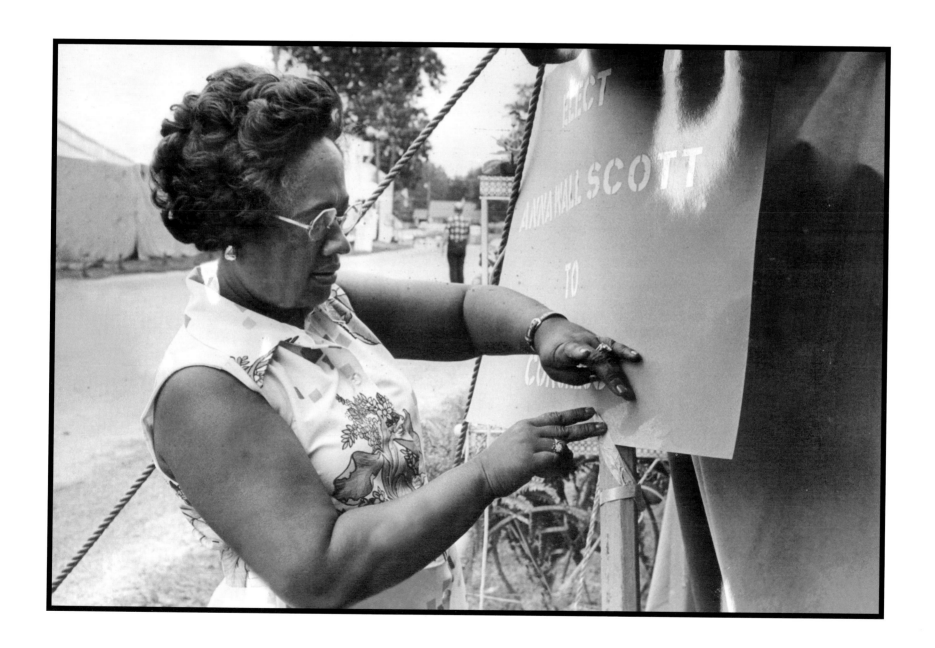

Full Steam Ahead

A steam shovel works on the Chicago and Eastern Illinois Railroad near Sidney. The railroad's passenger and freight service from Chicago to St. Louis passed through Rutherford Station, half a mile east of the town.

PHOTO COURTESY OF
THE CHAMPAIGN COUNTY
HISTORICAL SOCIETY

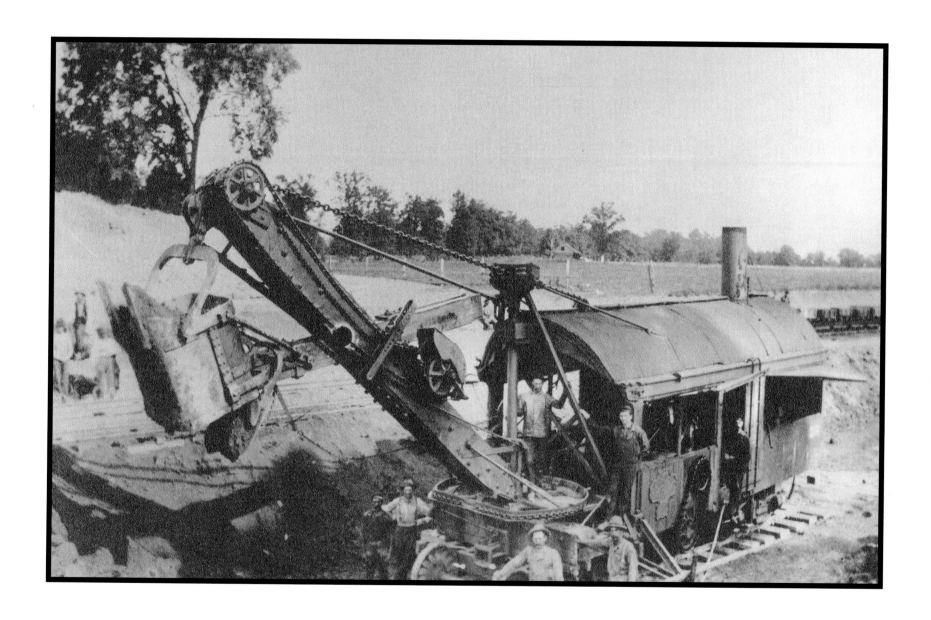

Welcome Home

World War I veterans, home from the front, form ranks for a parade in Ludlow in 1919. The war even influenced the country's music. Popular songs included "Over There" by George M. Cohan and "You're in the Army Now" by Isham Jones.

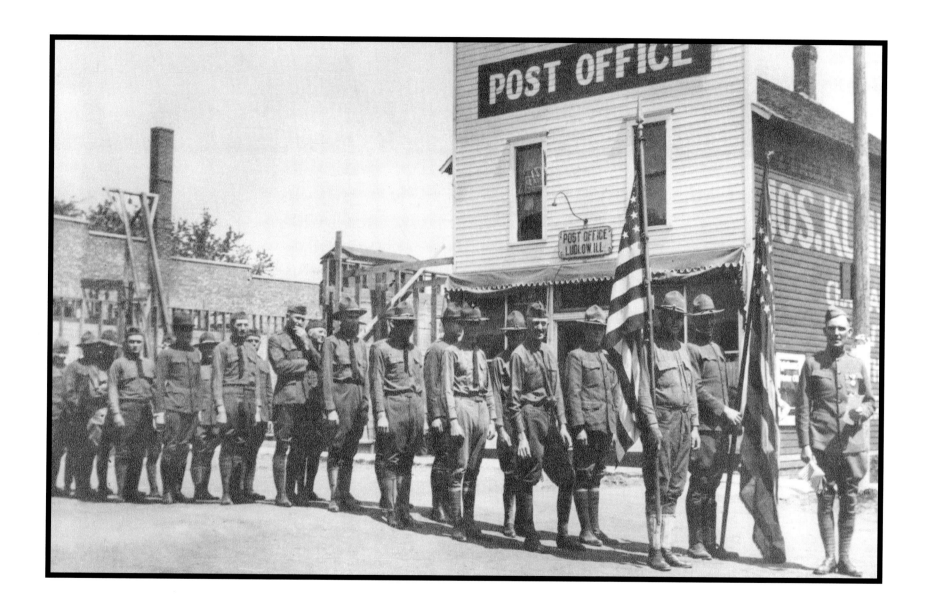

Champaign City Council

Mayor Dan McCollum (left) is photographed with John Lee Johnson, James Ransom, Jr., and Kenneth O. Stratton (left to right). Stratton, Ransom and Johnson were, respectively, the first, second and third African-American members of the Champaign City Council.

PHOTO COURTESY OF
MR. DANNEL MCCOLLUM

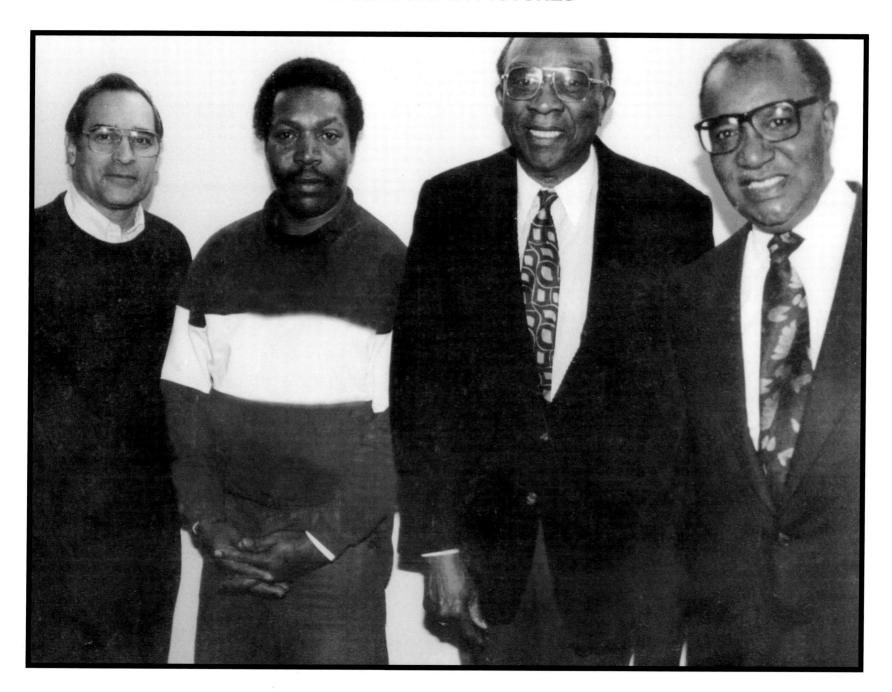

Nobel Prize Winner

University of Illinois Professor John Bardeen (center), shown
with John Corbally (left) and William Gerberding, won the Nobel
Prize in Physics in 1956 for the invention of the transistor. In
1972, Bardeen, Leon Cooper and J. Robert Schreiffer won the
prize for the theory of superconductivity, making Bardeen the
only person to win two Nobel Prizes in the same field.

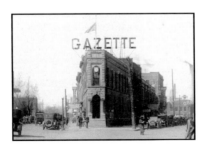

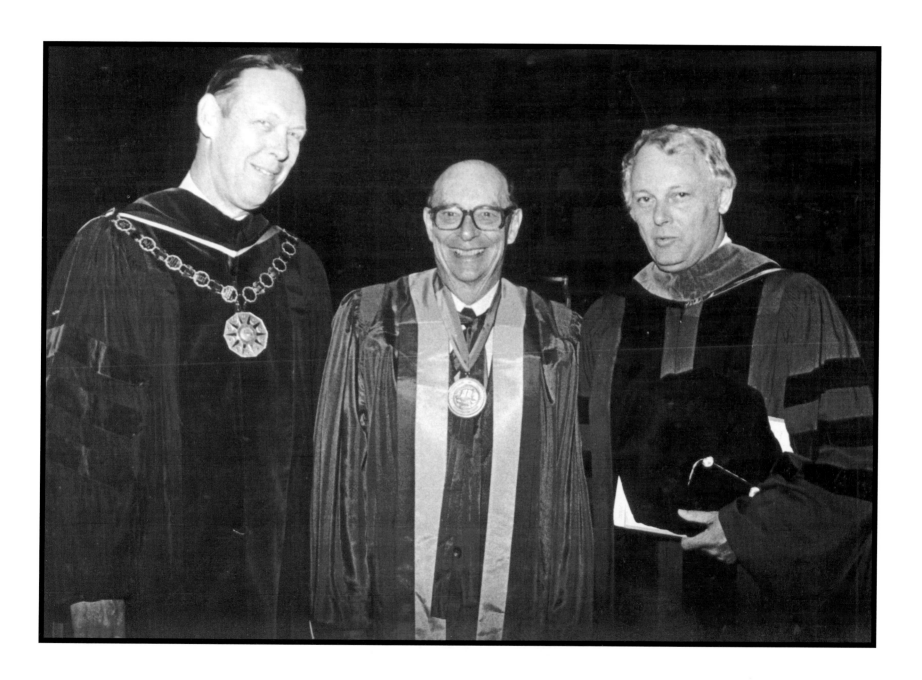

Freshman Initiation

The "Color Rush" was a university tradition when this picture was taken in 1906. Members of the freshman class tied their flag to a flagpole and then defended it from attacks by upperclassmen.

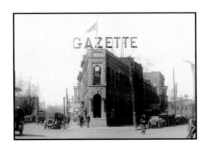

PHOTO COURTESY OF THE
CHAMPAIGN COUNTY
HISTORICAL SOCIETY

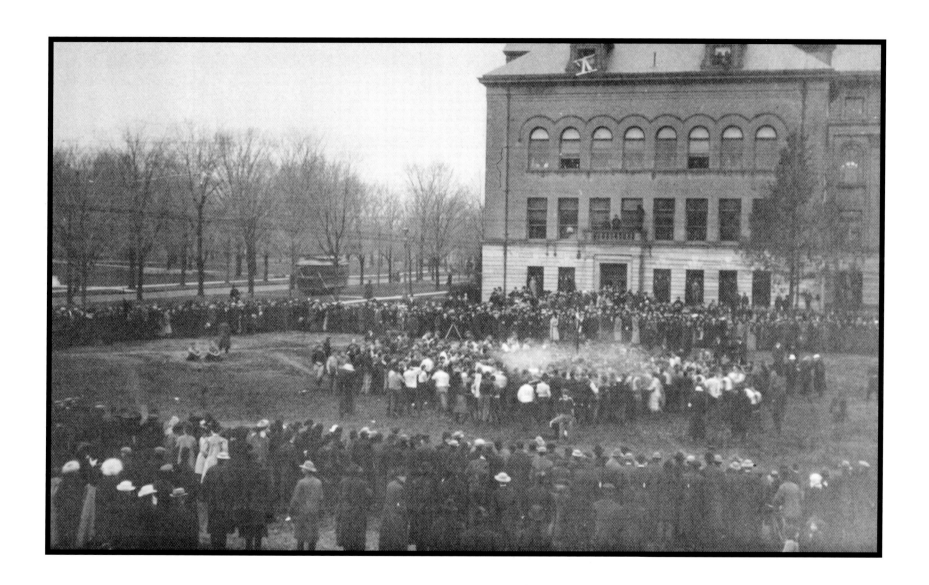

Clean as a Whistle

The Billy Noll Sanitary Laundry, shown with employees at the door and the windows and delivery wagons waiting in front in 1920, was located on North Walnut Street in Danville.

PHOTO COURTESY OF
THE VERMILION COUNTY
MUSEUM SOCIETY
COLLECTION

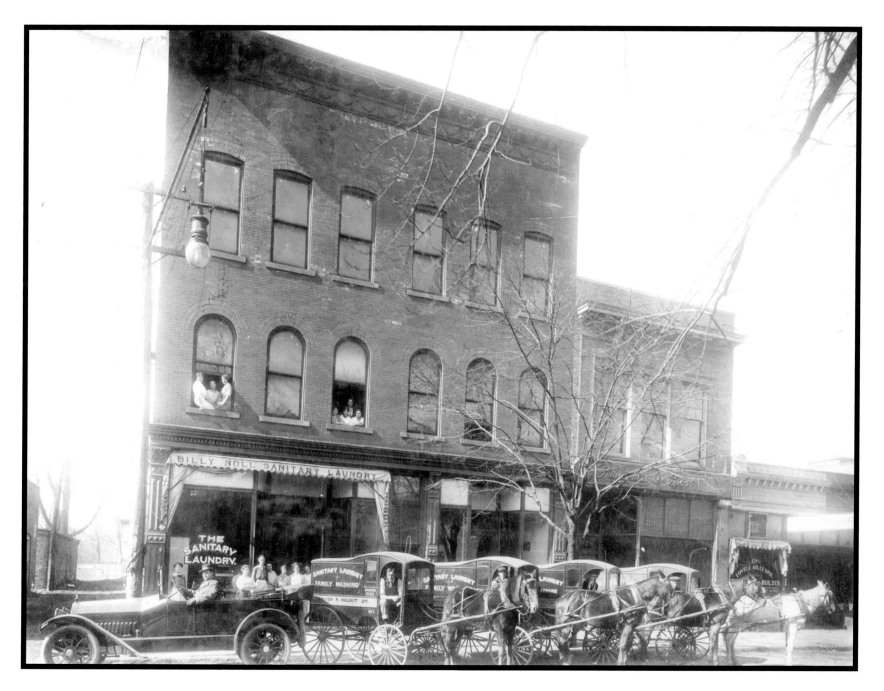

Tie a Yellow Ribbon

Marine Sgt. Paul Lewis, a Homer native, was one of the hostages held for 444 days in Iran. This photo of American Legion Post 290 in Homer demonstrates the town's support for Lewis, who was eventually freed with the rest of the hostages.

PHOTO COURTESY OF
THE NEWS-GAZETTE

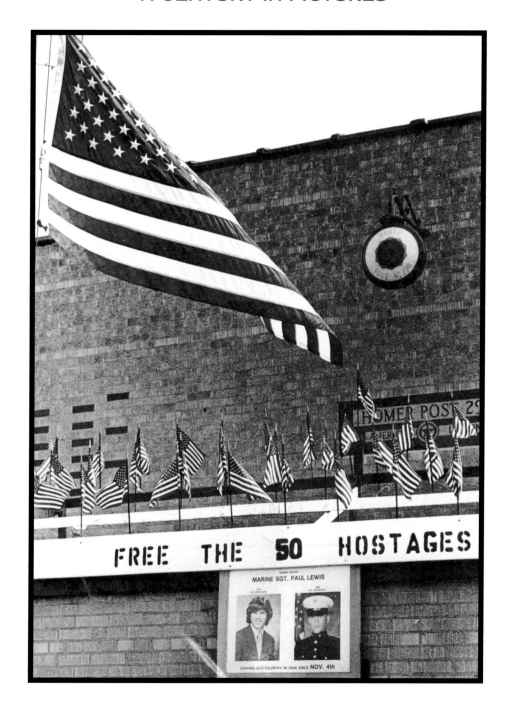

Daddy's Home

Marines who served in the Gulf War are greeted by enthusiastic family members upon their return home to Danville on April 14, 1991.

PHOTO COURTESY OF
THE NEWS-GAZETTE

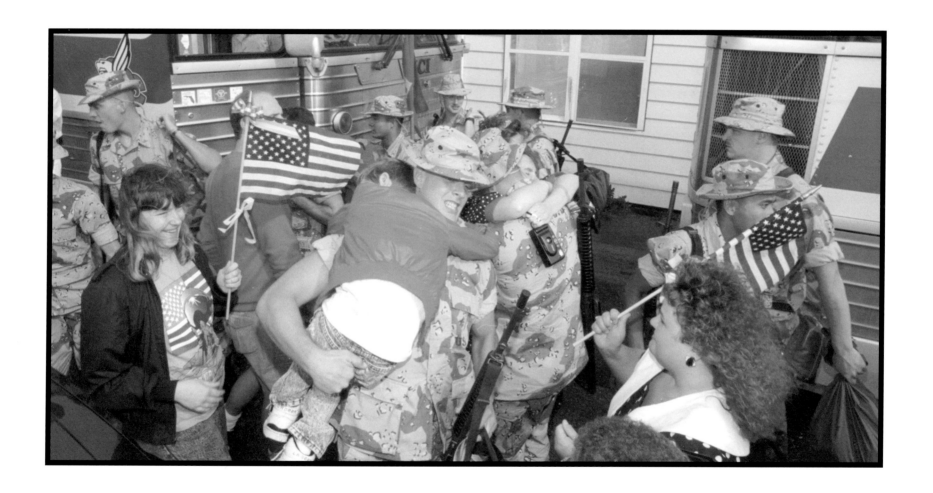

Farm Aid

The first Farm Aid concert, featuring country singer Willie Nelson, drew attention to the nation's farm crisis. The September 22, 1985, event drew more than 78,000 people to Memorial Stadium and raised about $10 million.

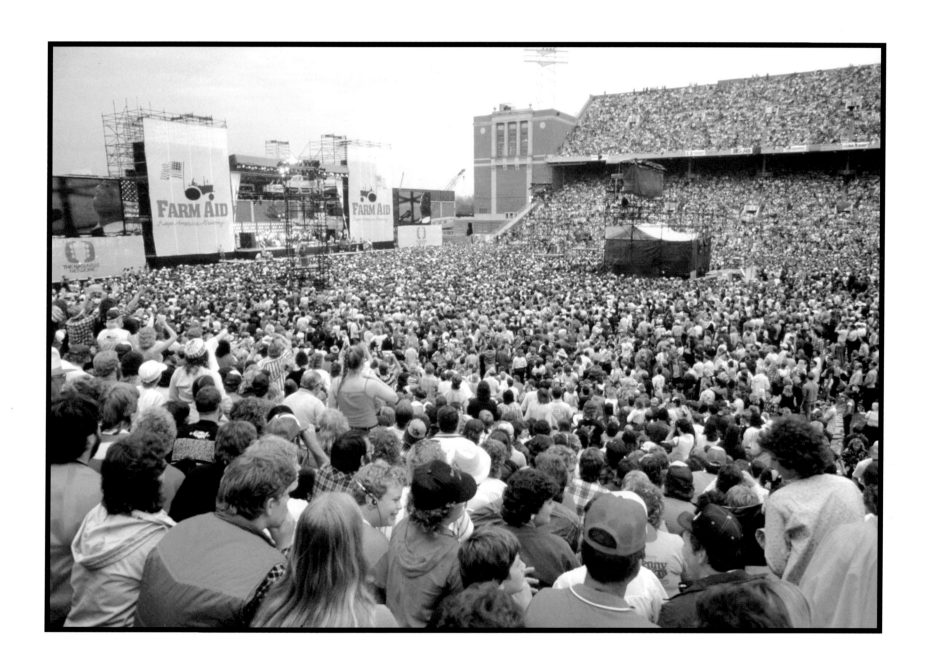

On the Air

Musician Pete Bridgewater also doubled as a broadcaster. In 1953, he hosted a radio show at WKID on Philo Road in Urbana.

PHOTO COURTESY OF
MR. PETE BRIDGEWATER

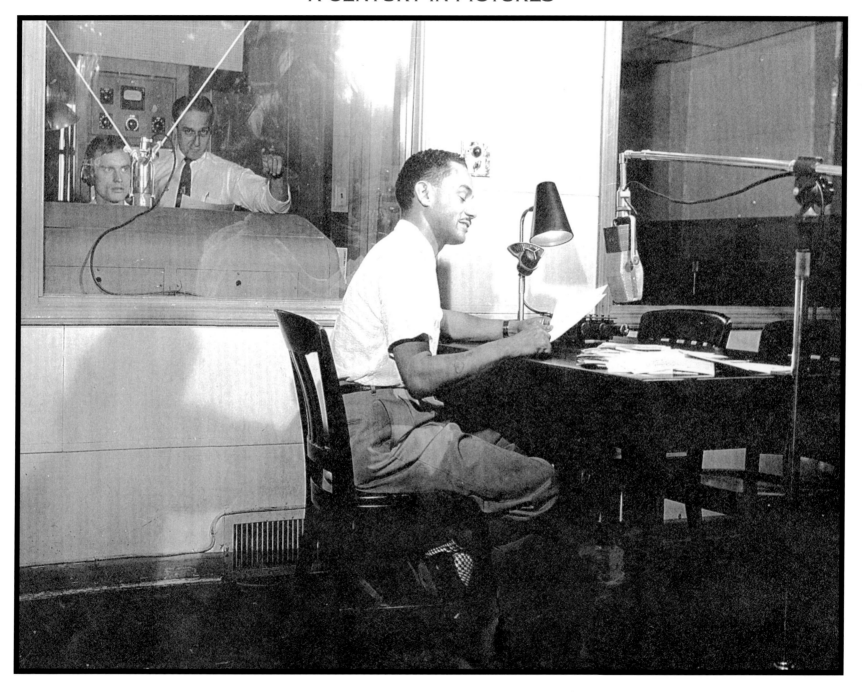

Horsepower

Men and children near Rantoul take a break from the business of farming early in the century. The size of the average farm in Illinois has more than doubled since 1950, from 156 acres to 352.

PHOTO COURTESY OF
THE RANTOUL
HISTORICAL SOCIETY

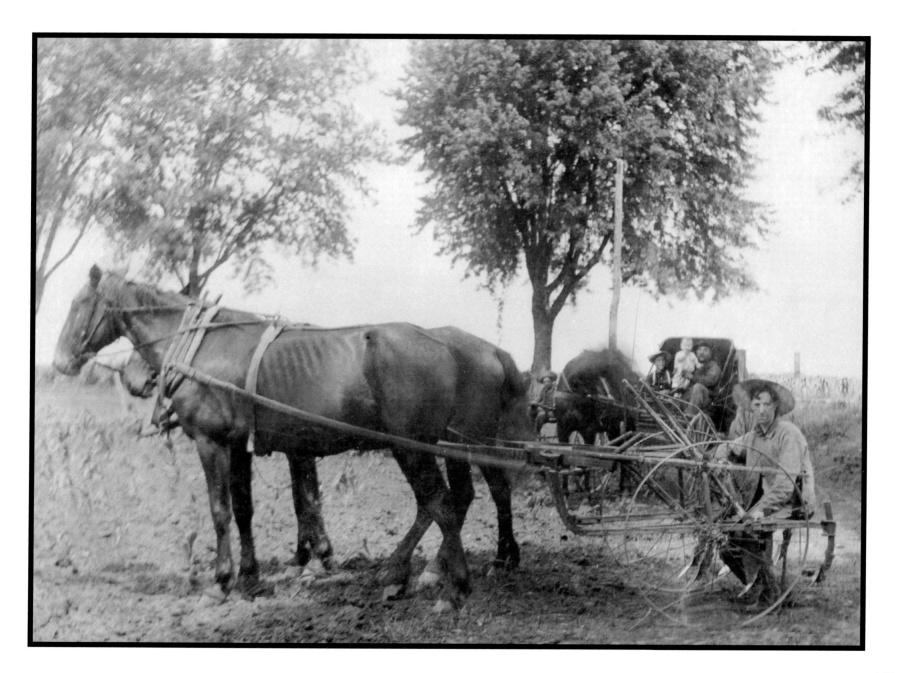

Mr. Thomas

Taylor Thomas holds the distinction of being the
first African-American teacher in Urbana. He taught
social studies at Urbana High School.

PHOTO COURTESY OF
MRS. DORIS HOSKINS

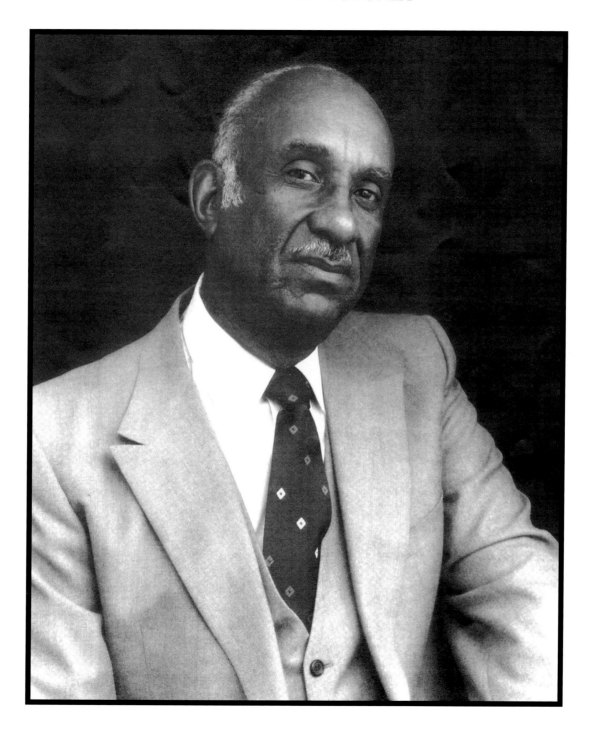

Ice Storm

On February 14, 1990, the Champaign-Urbana area was hit with an ice storm, leaving some residents without power for up to a week. This photo was taken near the corner of Union and Willis in Champaign.

PHOTO COURTESY OF
THE NEWS-GAZETTE

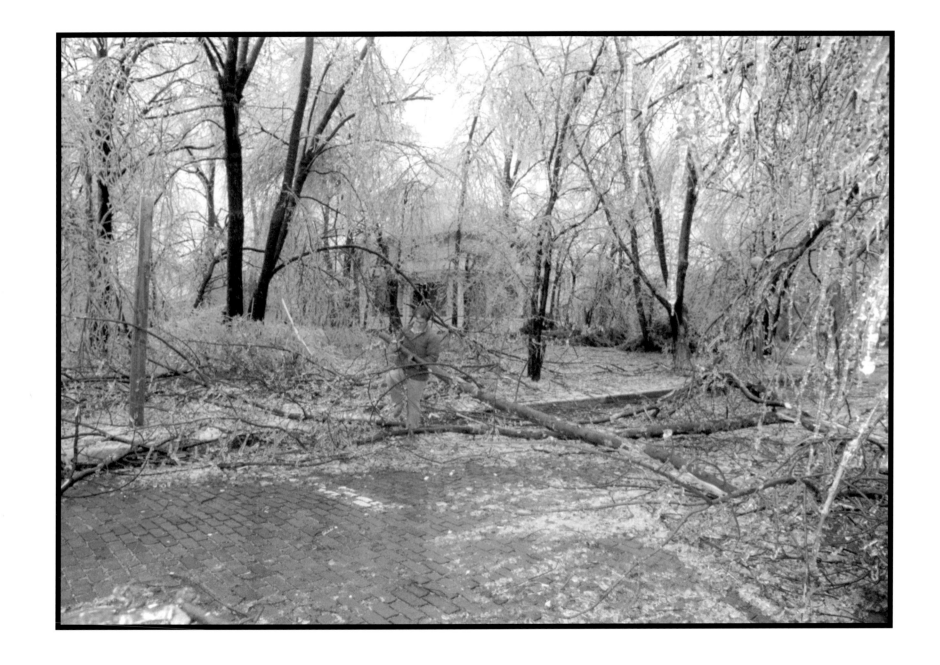

Any Vacancies?

The Urbana Lincoln Hotel, built for $500,000, opened in 1924 and served patrons until July 1975. A few years later, it was remodeled and reopened as Jumer's Castle Lodge.

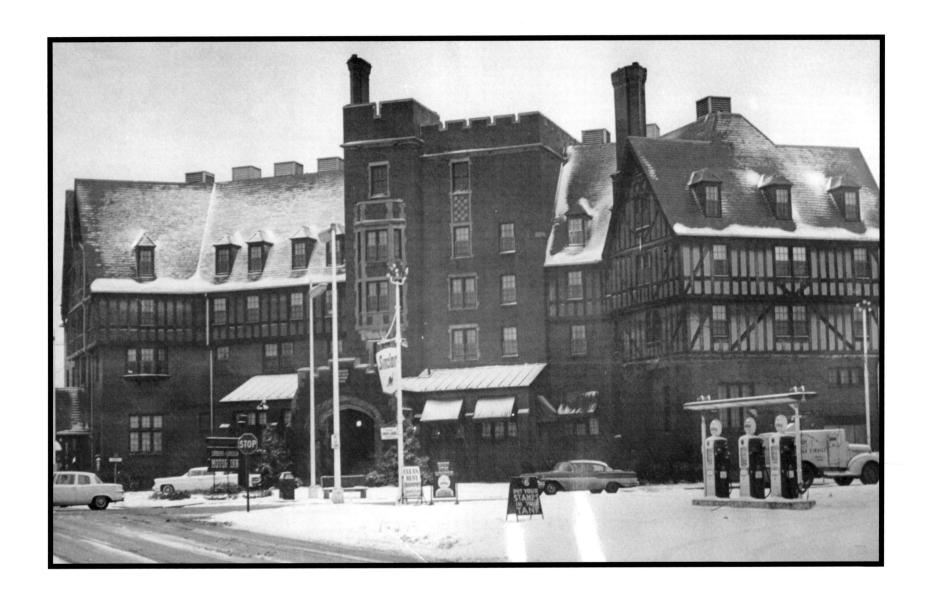

V-J Day

A sailor climbs a light post to celebrate V-J Day, August 14, 1945. He is in downtown Champaign in front of the old Kresge Building at the corner of Main and Neil.

PHOTO COURTESY OF
THE URBANA FREE LIBRARY

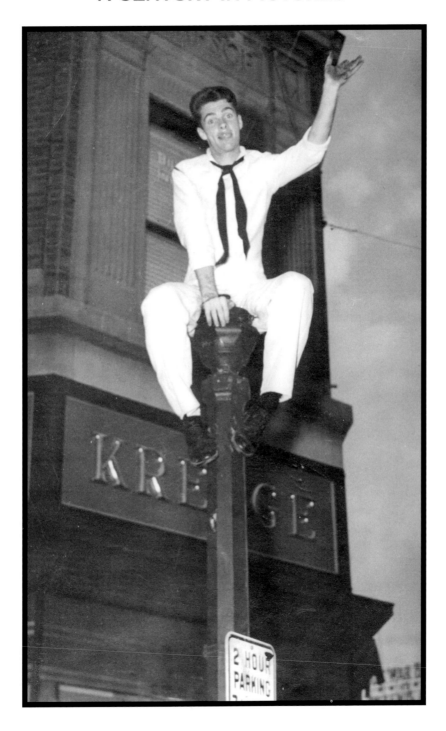

Firemen's Fourth

The Champaign Fire Department band marches in the
July 4, 1920 parade. This photo was taken looking west from
University Avenue and Chester Street.

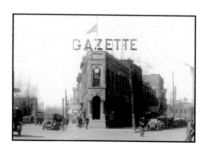

PHOTO COURTESY OF
MR. JAMES BARHAM

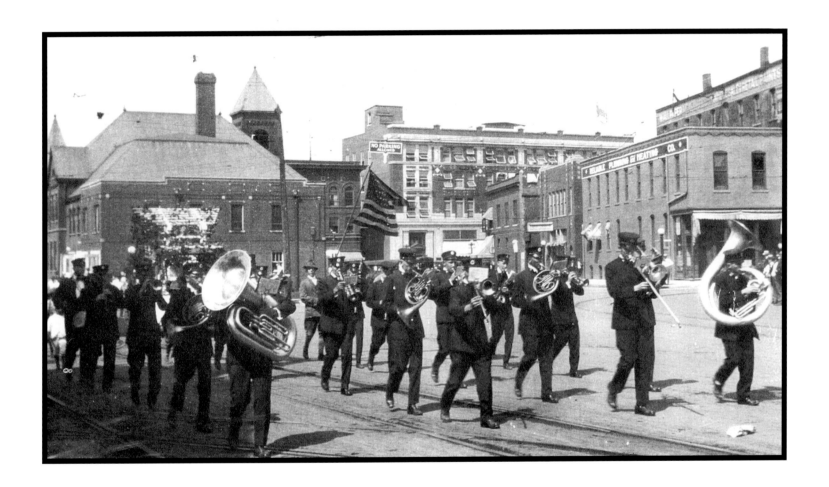

City Center

This view of North Vermilion Street in Danville shows the city's central business district, circa 1930. The courthouse is on the right, with the Daniel Building, now the Courthouse Annex, on the left. The Temple Building is in the background beyond the Daniel Building.

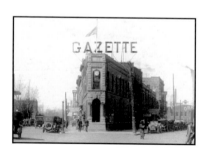

PHOTO COURTESY OF
THE VERMILION COUNTY
MUSEUM SOCIETY
COLLECTION

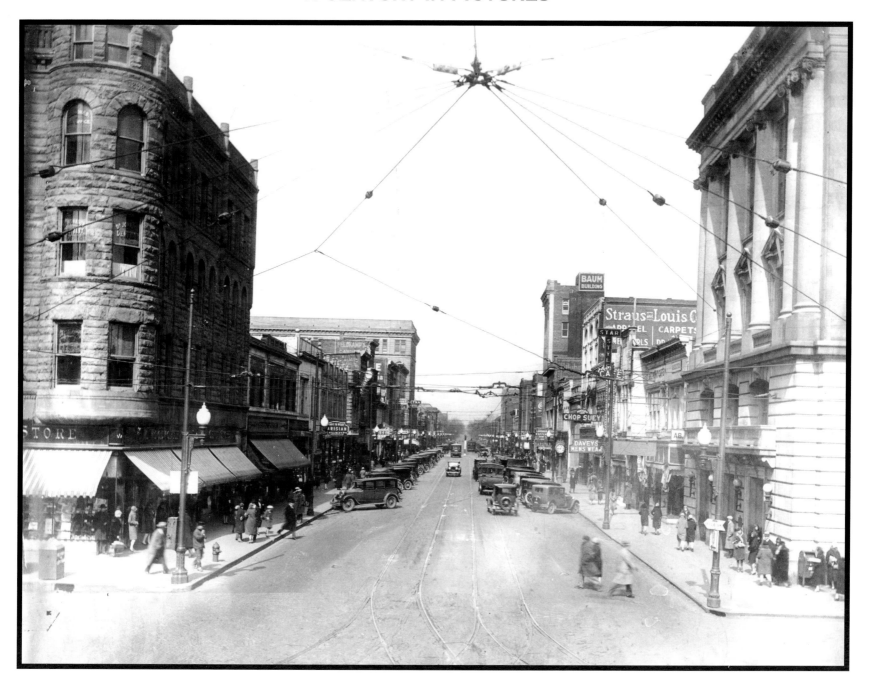

Saving Private Osborne

In 1931, Private Harold Osborne was performing a test jump when the lines of his parachute caught in the tail assembly of the plane, leaving him dangling in the air. A second plane lowered a knife, and Osborne cut the lines and then pulled the cord of his reserve chute to return safely to land.

PHOTO COURTESY OF
THE OCTAVE CHANUTE
AEROSPACE MUSEUM

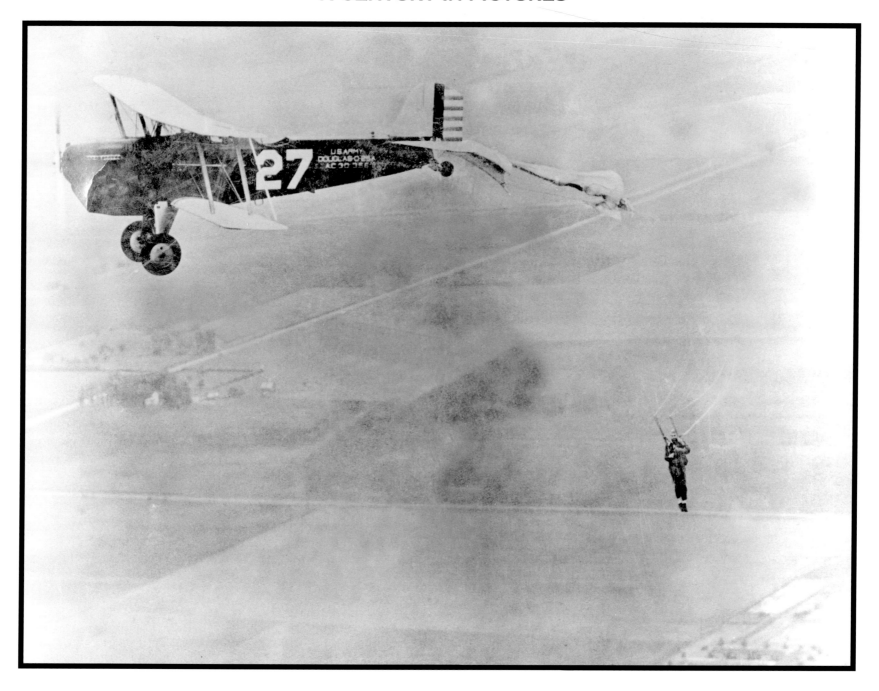

James Burgess, Esq.

James Burgess files for office at the Champaign County Court-house in 1971. Burgess was elected County State's Attorney, becoming the first African-American elected to a county office. He was later appointed a federal judge.

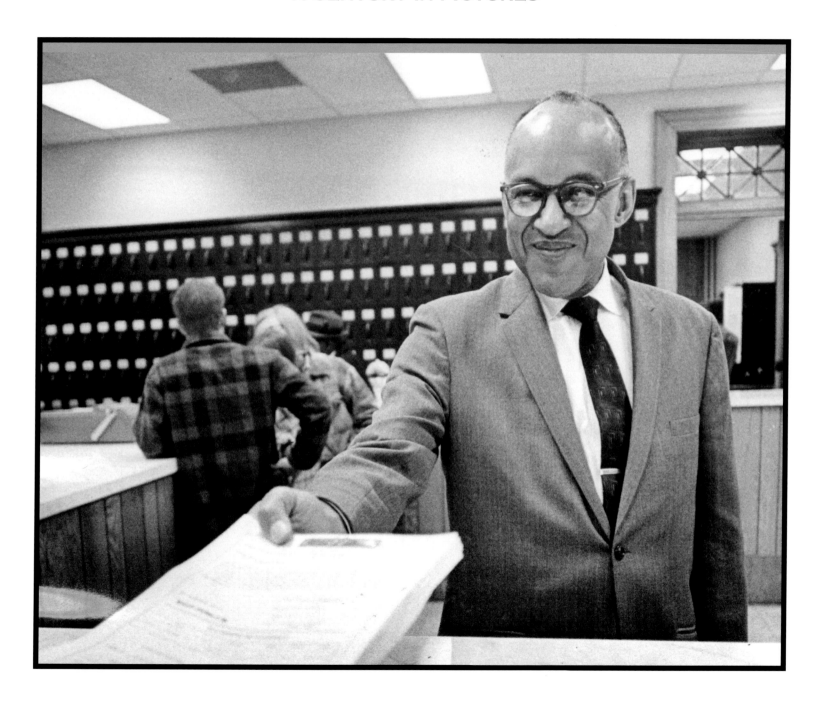

Where There's Smoke

Smoke from a fire in the building that housed the Black Cat Tap Room and Liquor Store rises over South Vermilion Street in Danville on June 8, 1949.

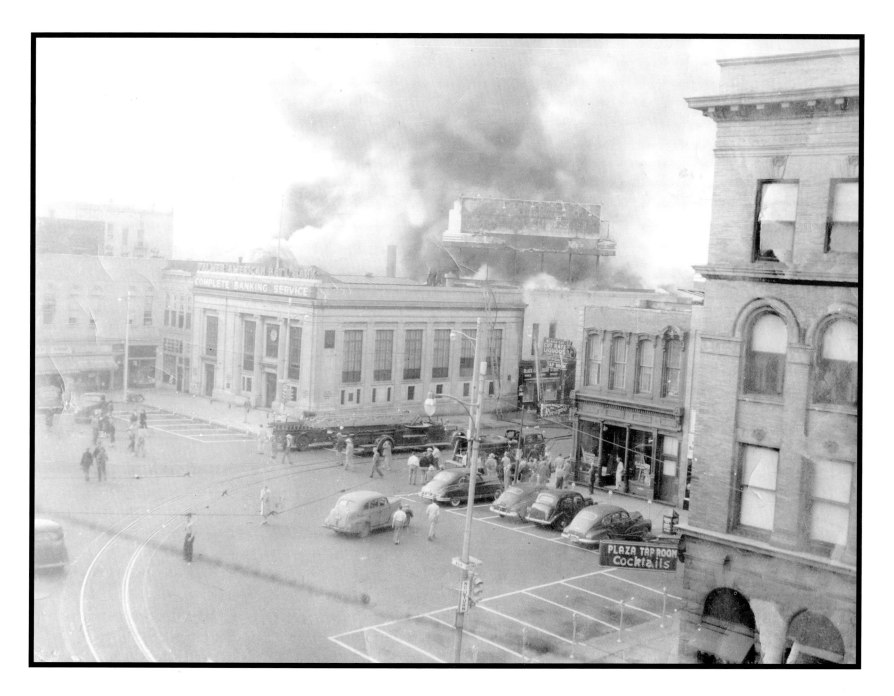

Commencement Parade

A streetcar line once ran south of the Illini Union on the University of Illinois campus. Here, one of the cars waits for the members of the 1924 commencement parade to pass before continuing its route.

PHOTO COURTESY OF
THE CHAMPAIGN COUNTY
HISTORICAL SOCIETY

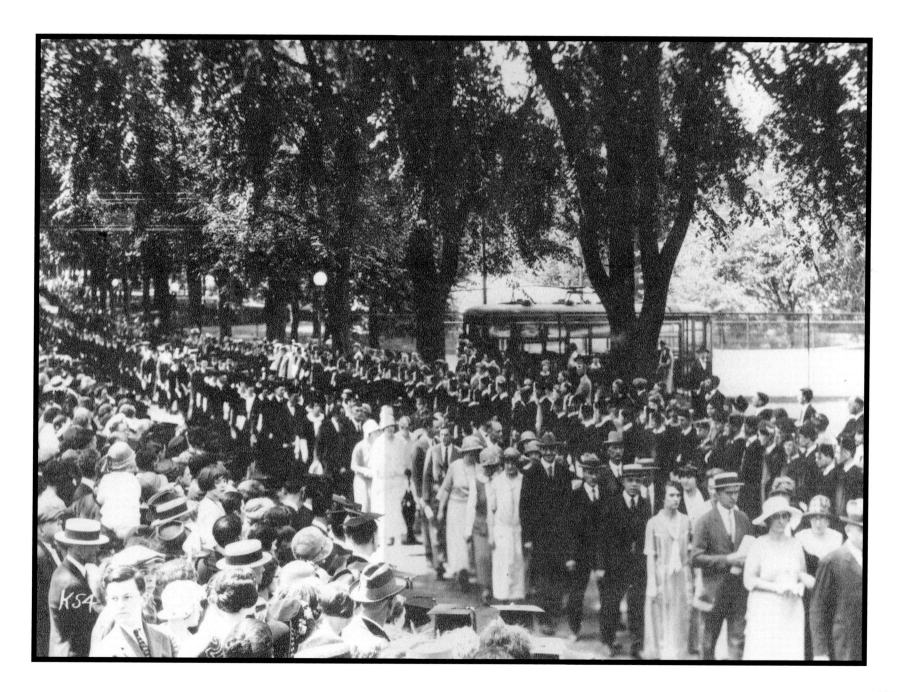

Virginia Theater

The Virginia Theater, built in the Italian Renaissance
style, opened on December 28, 1921. Today it is the site
of plays, concerts and other cultural events. This photo
was taken in 1968.

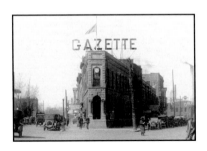

PHOTO COURTESY OF
THE CHAMPAIGN COUNTY
HISTORICAL SOCIETY

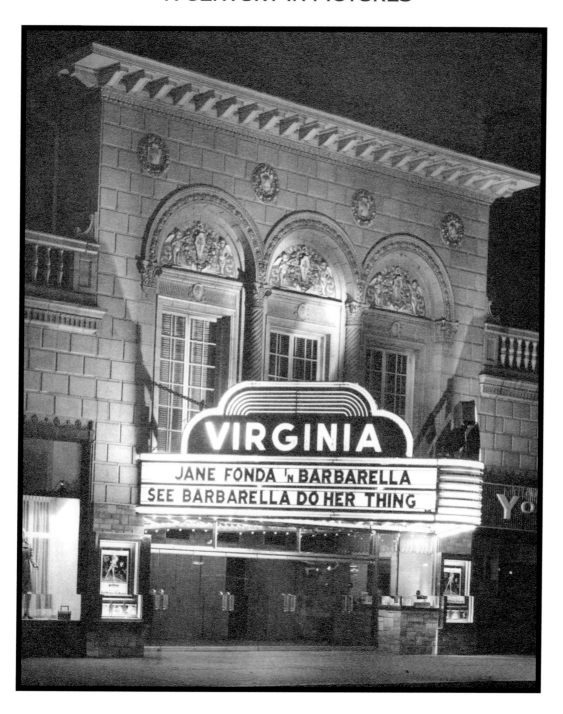

Hero

Lt. Harold Albert Wascher was awarded the
Distinguished Service Cross in 1918 for heroism at Nouart,
France. A printer and bookbinder, he owned Wascher's
Bindery near the University of Illinois campus.

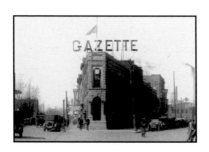

PHOTO COURTESY OF
MR. DWAIN BERGGREN

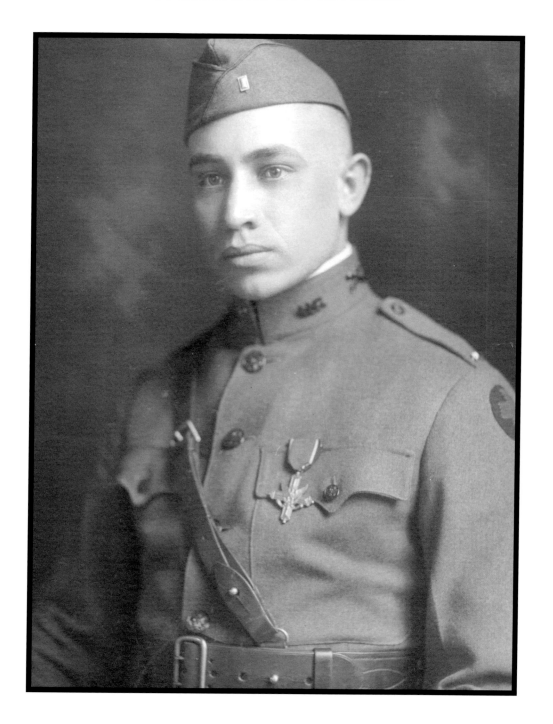

Tornado Strikes

On March 16, 1942, a tornado hit Champaign County, causing several deaths and overturning this truck at Myra Station, a few miles southeast of Urbana.

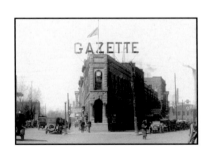

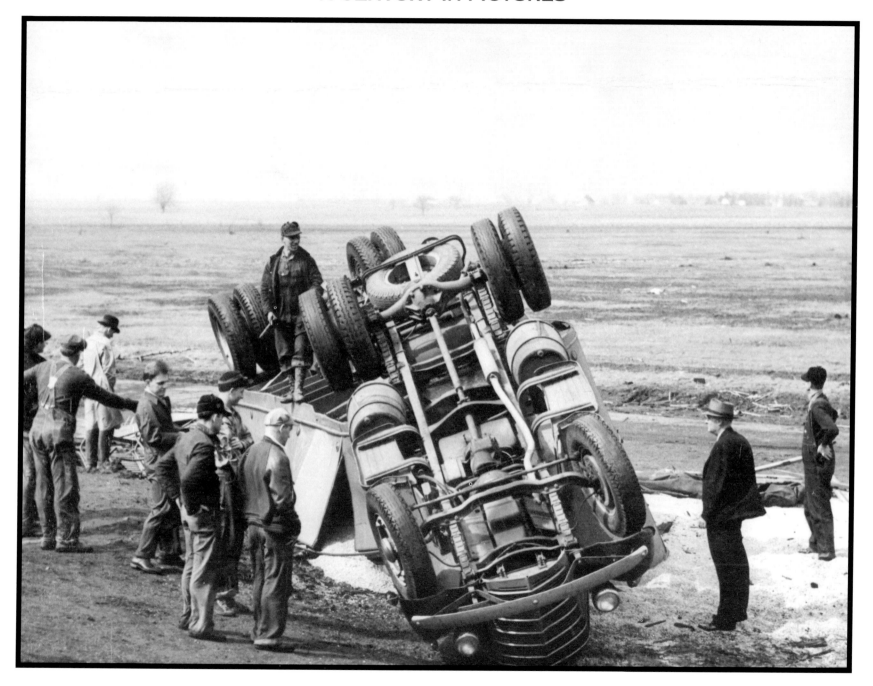

Iron Lady

The Flat Iron Department Store opened in 1906. The building was erected on the wedge of land between Springfield and Main in Urbana. A statue of Frances Willard, founder of the Women's Christian Temperance Union, stood in front of the building from 1907 to 1921.

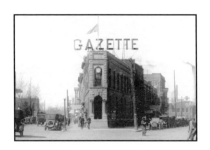

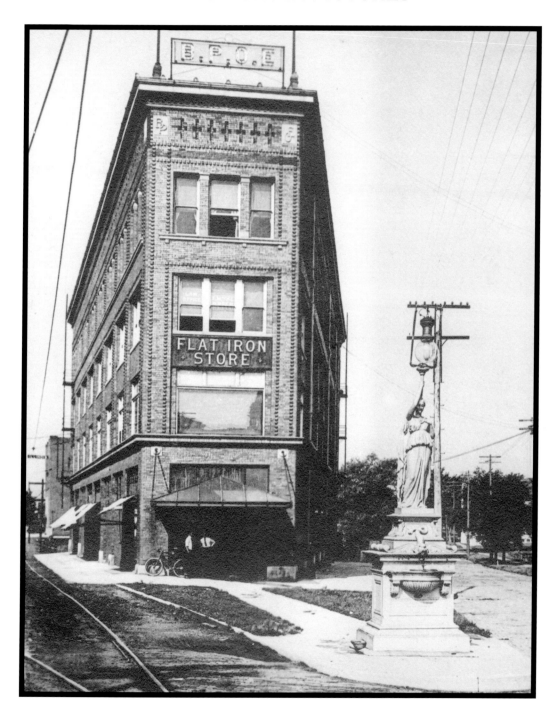

Department Store

Employees pose for a photo at the Roth Department Store, located on the first floor of the Flat Iron Building at Springfield and Main in Urbana.

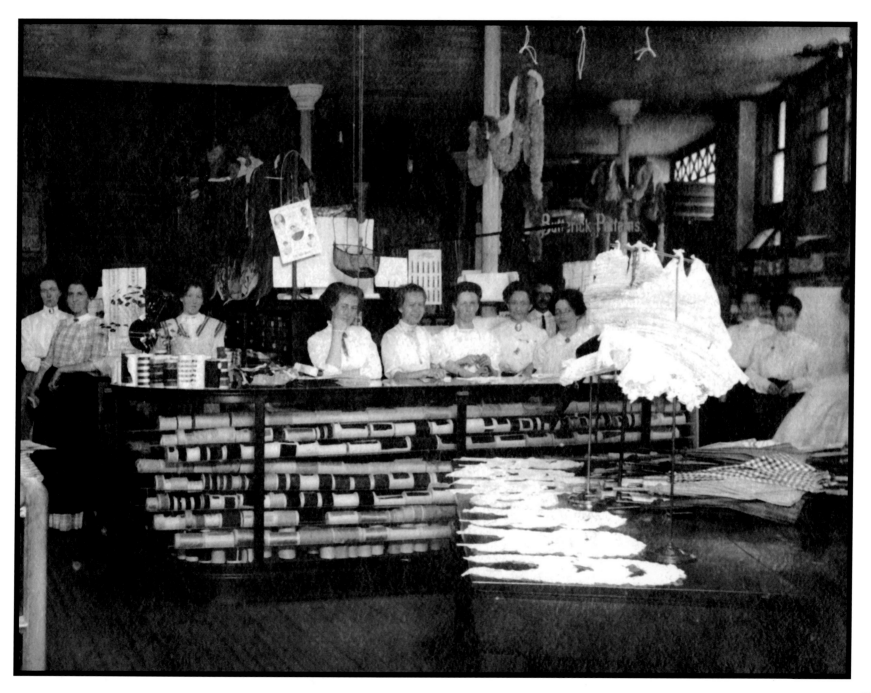

Holiday Lights

This photo shows the view looking west on Main Street in Champaign in December 1954. While the businesses have changed in the intervening years, many of the buildings remain the same.

PHOTO COURTESY OF
THE CHAMPAIGN COUNTY
HISTORICAL SOCIETY

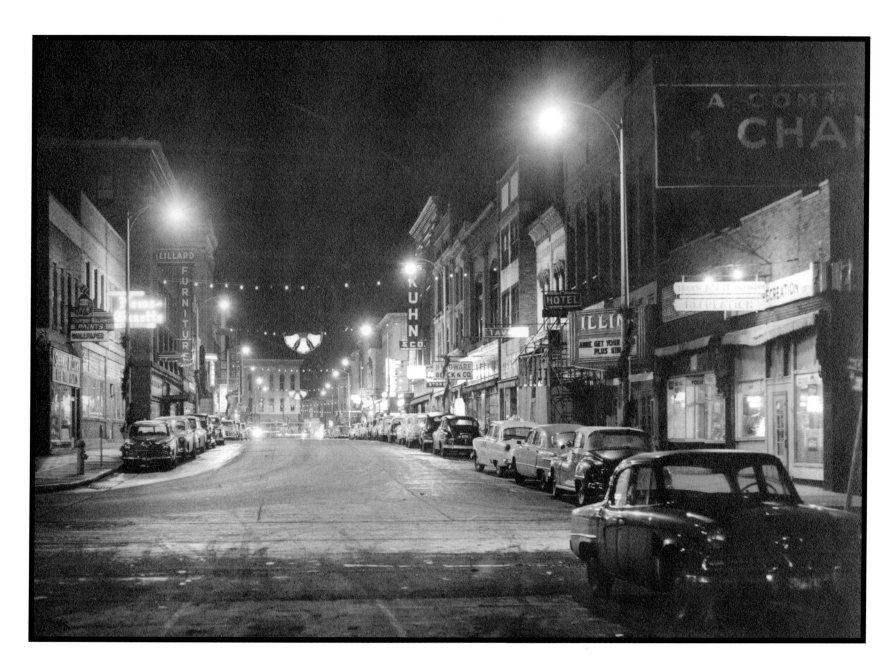

Window Shopping

This photo of the Mike Plautt and Co. store window shows off one of the Danville retailer's specials. The building is currently used for storage.

PHOTO COURTESY OF
THE VERMILION COUNTY
MUSEUM SOCIETY
COLLECTION

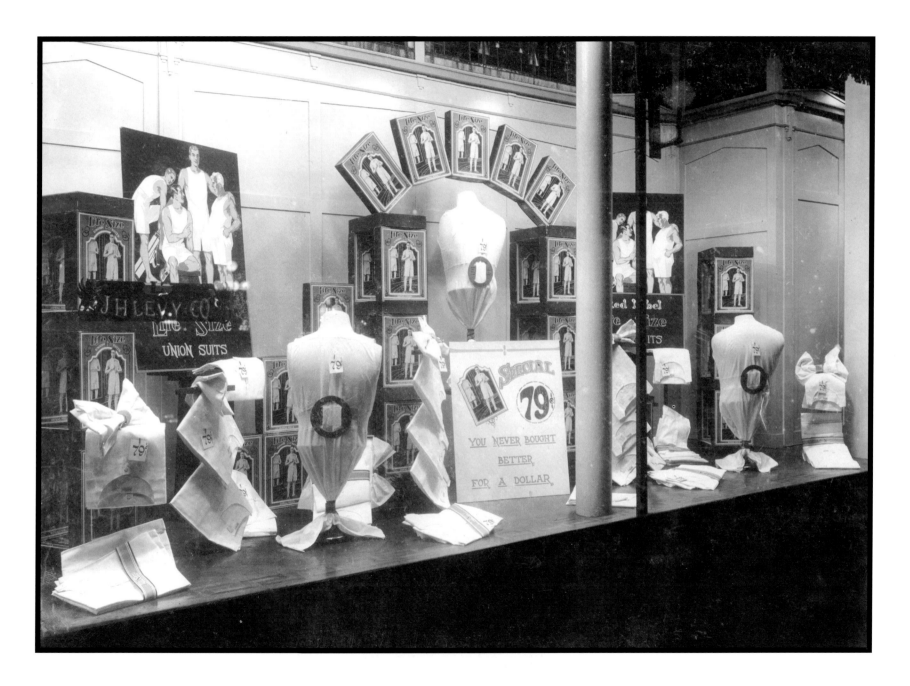

Missile Men

From 1961 until its closing in 1993, Chanute was the training ground for the Minuteman (ICBM) Missile program. Here, trainees learn to change a missile warhead.

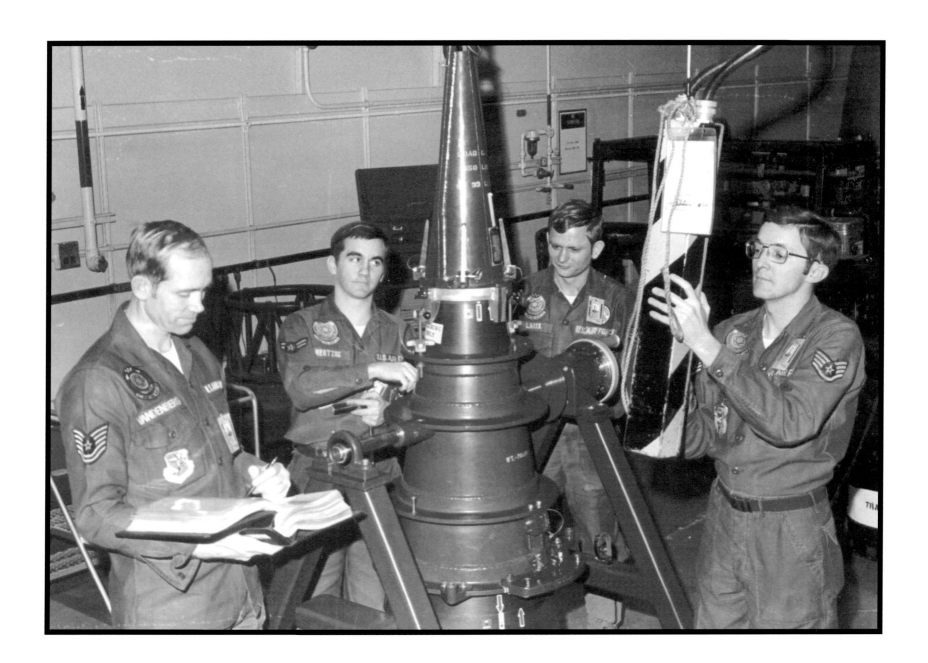

Engine House #2

Three firemen pose proudly beside their truck outside
Engine House #2, the African-American branch of the
Danville Fire Department, in the early 1920s.

PHOTO COURTESY OF
THE VERMILION COUNTY
MUSEUM SOCIETY
COLLECTION

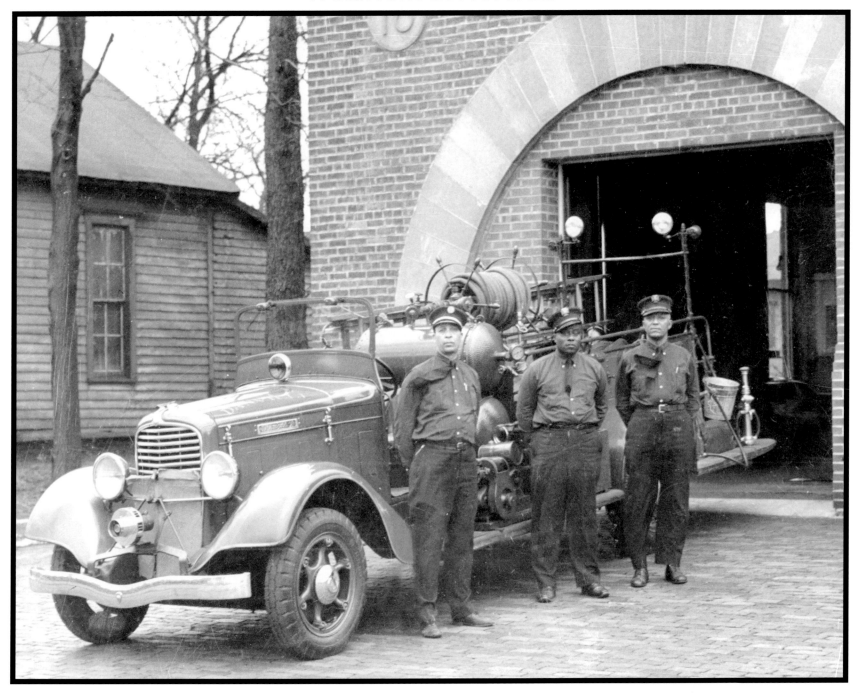

Law of the Land

This building, the fourth Champaign County Courthouse, was built on the courthouse square in 1861. The current courthouse replaced it in 1901.

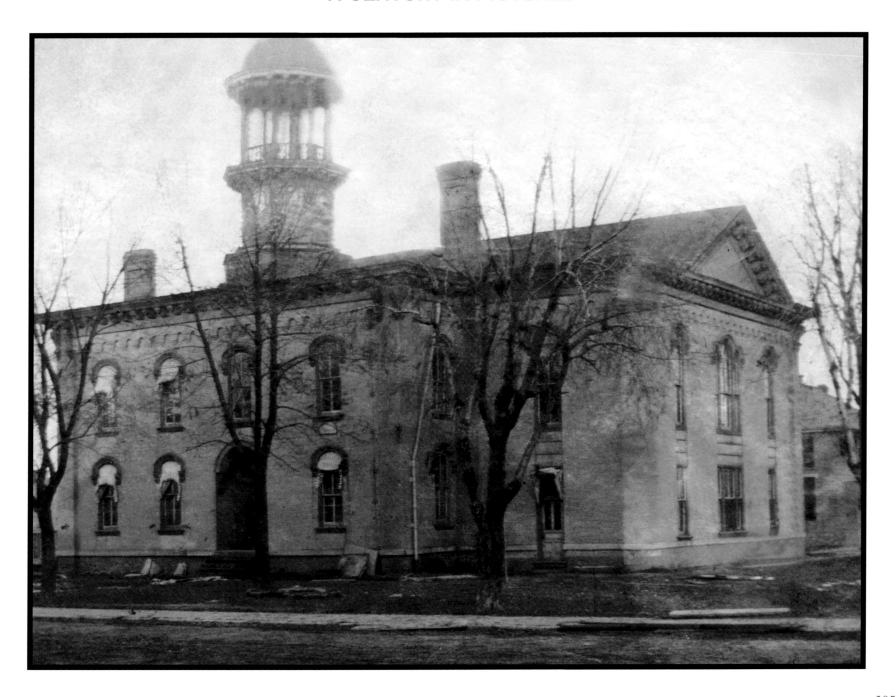

Bustling Downtown

This photo shows the view looking north from the intersection of Main and Neil streets in the 1950s. In August of 1969, the Flat Iron Building (center) was demolished to create room for more downtown parking.

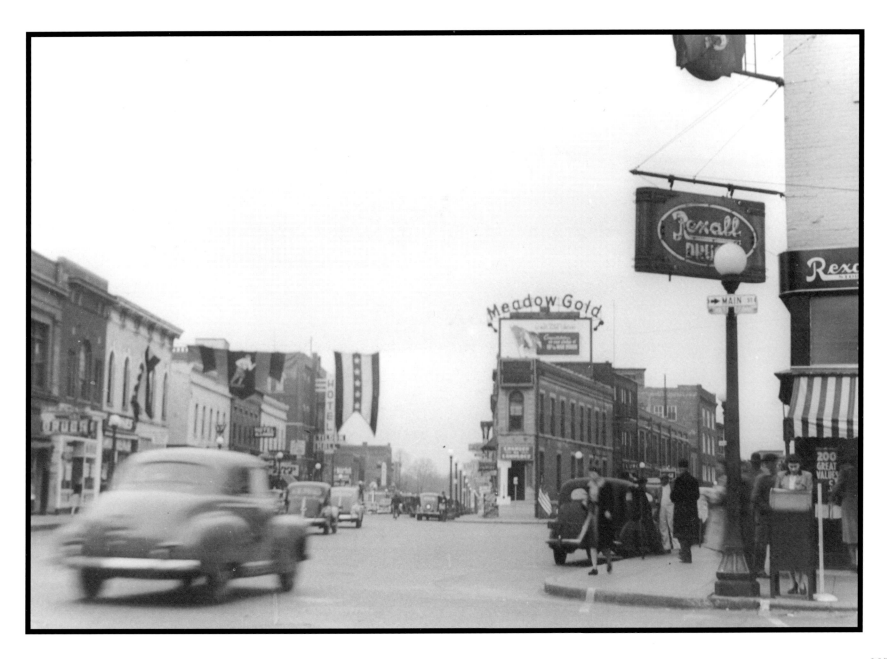

Acknowledgments

The pictures in this book came from a variety of sources. The people and organizations who contributed photographs and the history behind them include The Champaign County Historical Society, The Urbana Free Library, *The News-Gazette* photo archives, The Octave Chanute Aerospace Museum Foundation, The Vermilion County Historical Museum, C&U Poster Advertising Co., Helen McFeeters, Doris Hoskins, Betty Rowell, James Barham, Dannel McCollum, William M. Young, Pete Bridgewater, Eric Larson, Sue Richter, and Dwain Berggren. In addition, thanks to Rosemary Raeske and Jean Gordon for their research assistance.